KATHERINE MANSFIELD

LITERATURE AND LIFE: BRITISH WRITERS

Selected list of titles in this series:

Complete list of titles in the series available from the publisher on request.

KATHERINE MANSFIELD

Rhoda B. Nathan

576563

A Frederick Ungar Book

CONTINUUM · NEW YORK

1988

The Continuum Publishing Company
370 Lexington Avenue, New York, NY 10017

Copyright © 1988 by Rhoda B. Nathan

Printed in the United States of America

Library of Congress Cataloging-in-Publication Data

Nathan, Rhoda B.
Katherine Mansfield.

(Literature and life. British writers)
Bibliography: p.
Includes index.
1. Mansfield, Katherine, 1888–1923. 2. Authors,
New Zealand—20th century—Biography. I. Title.
II. Series.
PR9639.3.M258Z85 1988 823'.912 [B] 87-19191
ISBN 0-8044-2640-6

Contents

Introduction

There would be little point in writing still another biography of Katherine Mansfield. What Antony Alpers might have failed to note in his splendid updated day-by-day account of the New Zealand writer's short life, Jeffrey Meyers covered in his equally meticulously researched biography. Ida Baker, Mansfield's lifelong companion, added the dimension of personal intimacy in her memoir published under the initials L.M., for her pseudonym Lesley Moore. Finally, Claire Tomalin's *Katherine Mansfield: A Secret Life,* published in early 1988 as this book was going to press, emphasizes Mansfield's sexual history, a subject touched upon but not closely examined in the earlier studies.

The purpose of this critical study is to contribute some fresh insights into Mansfield's themes, techniques, and shaping influences. For example, her debt to Chekhov has often been remarked, but little has been made of the resemblance between his "Grasshopper" and her "Marriage à la Mode." The *Bildungsroman,* known as the novel of growth, has long been recognized as the province of writers as diverse as James Joyce and Mark Twain. This study analyzes Mansfield's short stories as such a cycle of maturation. Mansfield's painterly techniques, particularly those that link her with the impressionist painters of her time, are anatomized here. And the marked naturalism of some of her early stories places her in the category of such writers as Stephen Crane. Some of the critical observations in this book will inevitably reinforce the conventional judgment and interpretation of Mansfield's fiction, but some are entirely original and perhaps even controversial. In many cases I tell simply how the stories have struck me, both in reading and in teaching them, and sometimes I have gone against the popular critical grain in my analysis.

The salient facts of the author's life have not been entirely

overlooked. In addition to the relatively brief biographical chapter, wherever Mansfield's life has been reflected in her fiction the connection has been noted. Thus, her youthful trek through the Urewera wilderness has been discussed as biographical background to her early naturalistic story, "The Woman at the Store." Her own father was the original "pa man" on whom many of her male characters are modeled. That biographical fact is noted in the discussion of stories that draw from her familial life. Her own turbulent sexual and marital experience is reviewed as it provides the material for some of her most deeply felt stories of male-female interaction and conflict.

I have tried to keep the short story as genre in focus throughout, for I believe it is an art form worthy of serious consideration and in no need of apology for lacking in bulk, length, or complexity. As a practitioner of her craft, Katherine Mansfield, writer of short stories, likewise requires no defense but the kind of systematic analysis and critical judgment this study, among others, accords her.

Chronology

1888 Kathleen Mansfield Beauchamp, later known as Katherine Mansfield, born to Harold and Annie Dyer Beauchamp on October 14 in Wellington, New Zealand.

1897 Kathleen wins the Karori village school prize for composition with her story "A Sea Voyage."

1900–1902 Kathleen attends Miss Swainson's secondary school, where she meets the Maori Maata Mahupuku, with whom she later has a love affair.

1903 Kathleen enters Queen's College in Harley Street, London. She meets Ida Baker, whom she will give the name "Lesley Moore" after her brother. L. M. will remain a lifelong friend and will write a posthumous memoir of her companion.

1907 In March Mrs. Beauchamp gives a garden party whose success is clouded by a cottager's accidental death. The episode is the germ of "The Garden Party" in 1911.

1909 Kathleen marries G. C. Bowden, age thirty-nine, after a brief acquaintance, and leaves him that evening without consummating the marriage. She joins her girlhood friend Garnet Trowell, a Wellington-born cellist, and becomes pregnant. Kathleen's mother takes her to Bad Wörishofen in Bavaria to await her baby's birth, but Kathleen miscarries in June. The sketches and stories in *In a*

German Pension are based largely on her experience in the Hotel Kreuzer during her confinement.

1910 Kathleen begins using the name "Katherine Mansfield" both personally and professionally. She remains "Kass" to the members of her family, as her correspondence reveals.

1911 Katherine meets J. Middleton Murry. He is twenty-two and the editor of *Rhythm* magazine. *In a German Pension* is published by Stephen Swift, as one of his list of "Books that Compel." It is her first published book, advertised as a "six-shilling novel."

1912 J. Middleton Murry moves in with Katherine and becomes her lover.

1914 On July 13 Murry and Mansfield witness the marriage of Frieda Weekley and D. H. Lawrence. Frieda gives Katherine her old wedding ring, which Katherine wears until her death.

1915 On October 7, Katherine's beloved brother Leslie is killed in France during World War I. From that time on, according to her *Journal* entries and letters, her life is irrevocably altered by grief for the boys whom she refers to as "Bogey" or "Chummie." Eventually she begins to call Murry "Bogey" in her letters.

1918 Katherine begins a friendship with Virginia Woolf. On July 10 *Prelude*, begun as *The Aloe*, is published by Virginia and Leonard Woolf's Hogarth Press. On May 3 Katherine and Murry are married. In August "Bliss" is published in the *English Review*. On August 8 her mother, Annie Dyer Beauchamp,

dies. Many of her daughter's fictional characters, including Linda Burnell, Mrs. Sheridan, and Janey in "The Stranger," were based on her mother's life and character. Katherine experiences her first grave symptoms of tuberculosis. She develops a persistent cough, is diagnosed as having a spot on her lung, and suffers her first hemorrhage.

1919 Katherine begins reviewing novels for the *Athenaeum*, a new literary journal for which Murry has been appointed editor.

1920 Katherine writes "Je ne parle pas français," "Miss Brill," and "The Daughters of the Late Colonel." Her collection, *Bliss, and Other Stories* is published by Constable in December.

1921 Katherine writes *At the Bay*, a sequel to *Prelude*. She finishes "The Garden Party" and "The Doll's House" and publishes "Marriage à la Mode."

1922 On February 23 Constable publishes the collection *The Garden Party, and Other Stories*. Katherine writes "A Cup of Tea," "Taking the Veil," and "The Fly." In October, hoping for a cure for her worsening disease, she goes to the Institute for the Harmonious Development of Man in Fontainebleau. Under the influence of its founder, a charismatic mystic named George Ivanovich Gurdjieff, she subjects herself to a regimen of diet, exercise, and rest.

1923 On January 9, with Murry having just arrived to visit her for the first time, Katherine dies of a violent hemorrhage. She is buried on the next day at the cemetery at Avon near Fontainebleau.

1

The Life as Source

There is scarcely an artist in history whose life is not reflected in some significant way in his work. It is left to the biographer to discover and illuminate the connections between the subject's life and work, keeping in mind the fact that the artist bends, distorts, and reshapes the facts of his life to suit his private vision. In Katherine Mansfield's case, the successive stages of her life are clearly reflected in her fiction. The major events correspond directly with the primary subjects of her stories: the New Zealand childhood; the education and periods of expatriation; the love affairs and uneasy marriages; and finally, the pain, isolation, and increasing "inwardness" generated by the inexorable course of her illness that was to terminate her career and her life at the age of thirty-four.

The writer whom readers know as Katherine Mansfield was born Kathleen Mansfield Beauchamp on October 14, 1888, at 11 Tinakori Road in Wellington, New Zealand.[1] The literary "Katherine"—she abandoned her given name in print at an early age and personally somewhat later in 1910—emerged as early as 1897 when she won a school competition with a story called "A Sea Voyage." Kathleen, nicknamed "Kass" by the members of her family, was the third of six children born to Harold and Annie Burnell Dyer Beauchamp, the first five of whom were daughters and the sixth a boy named Leslie. The only son, a great personal favorite of his father and his writer sister, died at the age of twenty-one during World War I. His death, a grotesque acci-

dent, was caused by the inadvertent detonation of a hand-held grenade during a military training session. Leslie, who was holding the grenade, and his sergeant, were both killed. Another Beauchamp child, Gwen, next in line after Kathleen, died in infancy.

With the exception of a cousin named Elizabeth von Arnim, who wrote a best-selling romantic novel called *Elizabeth and her German Garden*, the Beauchamp family was solidly mercantile. Katherine's grandfather, Arthur Beauchamp, began his career as something of a ne'er-do-well, migrating from England to New Zealand after the decline of his family's silversmith business. Failing to secure a parcel of land left him by a wealthy New Zealand relative, Beauchamp then moved on to the Australian goldfields, returning to New Zealand for good when he failed as a prospector. This time he succeeded as a general merchant and laid down the foundation of the family fortune.

In the nineteenth century New Zealand was a pioneering country to which the British came primarily for the purpose of making money. Arthur's son Harold, colonial to the core, prided himself on his rapid rise to material success. Leaving school at fourteen, he joined his father's company and later moved on to a large importing firm where in short order he became a partner. By 1907 he was chairman of the Bank of New Zealand and a wealthy and respected member of the provincial community of Wellington. Knighted later in life for his many civic contributions, he was, even in his earliest manhood, the model of the proper and conventional colonial Englishman who was to feature prominently in a number of guises in his daughter's fiction. Under his authority the Beauchamp family was secure and privileged, and if Katherine and her sisters went to the community school with the postman's and farmers' youngsters, it was only because it was the only educational institution available to her family in that frontier settlement.

Katherine's mother, grandmother, and young maiden aunt also appear frequently in her fiction, presented as the Sheridans

and the Burnells in the New Zealand stories. The author did not even bother to alter her mother's own surname, using the maternal "Dyer" and "Burnell" on occasion. In real life she often affixed the names of her family members to friends and lovers, calling her schoolmate Ida Baker "Lesley" after her beloved brother Leslie, and her husband John Middleton Murry "Bogey" after that same brother's pet name. Another family member, her uncle Valentine Waters, and his sons Eric and Barrie, became Jonathan Trout and his two sons Pip and Rags, affectionately drawn but impecunious relatives in "At the Bay." Katherine's parents, by contrast, decorous and deeply devoted to each other, are portrayed over and over in the light of their troubled daughter's shrewd understanding and ambivalent regard for them. Harold, the model for Katherine's recurrent portrait of the "pa man,"[2] was a conservative, didactic, and materialistic man whose tenderness was reserved for his beautiful and elegant wife, Annie, who clearly admired her domineering husband and just as clearly disdained his aggressive energy. She became the model for the detached and frail Linda Burnell of the New Zealand stories, loving her husband but resentful of her repeated maternity and aloof from her many children. Whatever nurturing Katherine enjoyed was at the hands of her maternal grandmother, who cheerfully fulfilled the domestic and familial duties her burdened daughter would not perform. The Mansfield *Journal* is a repository of illustrative recollections such as the note commemorating the birth of the newest ill-fated baby:

"Her name is Gwen," said the grandmother. "Kiss her. . . . Now go and kiss mother." . . . But mother did not want to kiss me. Very languid, leaning against some pillows, she was eating some sago.

The three successive Beauchamp residences, the first and last on Tinakori Road, with a rural Karori interlude, all serve as settings, both real and psychological, for some of the most telling stories of location and dislocation. Moving, with its attendant

disorientation, settling in, and readjustment, is a powerful theme in "Prelude" and other stories told from a child's-eye view. The houses themselves, more spacious and substantial with each rise in Harold's fortune, call forth from the author a deep appreciation of their beauty and luxury, as in her detailed description of the Sheridan house in "The Garden Party," as well as a discomfited awareness of the poverty of her neighbors. These mixed emotions of pleasure and guilt generated by her family's privilege are carefully preserved in "The Doll's House." Her family's snobbery of rank and her own sentimental identification with the working classes generate a carefully controlled tone of confusion natural to a young girl who is coming of age and inclined to idealize experience outside her personal limited range and scorn her haven as narrow and unchallenging. All the Beauchamp relations, neighbors, and servants find their way into the New Zealand stories, from her father's handyman Pat Sheehan, the central figure in the celebrated duck-decapitation episode in "Prelude" and in the sketch "About Pat," to the kindly but inelegant Jewish neighbors on Tinakori Road, who, as the fictional Samuel Josephs in "Prelude," help to mind the Burnell children during the family's hectic move to the country.

Personal beauty, parental favoritism, social magnetism, and academic success—the "chips" or commodities on which Katherine's sisters and friends traded in the conventional and class-conscious world of her childhood—were all denied to the young Kass. In a family of attractive and tractable siblings, she was homely, fat, severe, and contentious. The early photographs reveal a sullen face made forbidding by steel-rimmed spectacles and a limp hairdo. A stutterer like the young heroine of "The Little Girl" and "New Dresses," and openly defiant of her parents and teachers, Katherine stood out in a family of docile girls and a favored long-awaited son. Further, the intractable girl exacerbated her position through her uncertain temper and undistinguished record at school, which she herself characterized in later years as a period of idleness.[3] At the Wellington High

School, she was described by her headmistress as "surly" and given to untruthfulness. Nevertheless, she showed early evidence of writing talent in her first published short story, "Enna Blake," which even the headmistress praised. In every other way, however, she remained willfully isolated and rebellious, much as Helen, in "New Dresses," is portrayed—rambunctious, troublesome, and appreciated only by those willing to take the trouble to see beneath the surface of her petulance.

The young rebel's first opportunity to escape her confining environment came in 1903, when her parents agreed to have her attend Queens College in London in the company of her two older sisters and her young maiden aunt, Belle Dyer. Katherine was only fourteen. Though she was to return to New Zealand a number of times thereafter, that date marked the beginning of her intellectual, if not emotional, freedom from her country of origin. While some of her finest stories are rooted there, they are poignant precisely because of that fact of separation, drawing on a long formative period viewed from an unbreachable distance.

Queens College first, and Europe in general, provided the young girl with the nourishment her independent and questing spirit demanded. Her teachers, men of exceptional ability and availability to the small number of girls in residence, acquainted her with the fin de siècle theories and art of Walter Pater and the decadents of the 1890s as well as the literature of Tolstoy and Ibsen. Her *Journal* was peppered with epigrams drawn from Oscar Wilde, for whom she conceived a worshipful admiration, and whose effect is to be seen in stories such as "Marriage à la Mode." Katherine, who was a fair amateur cellist, resumed her music lessons in London, attended concerts, haunted her professors' rooms, and began writing in earnest. She published five stories about her childhood between 1903 and 1905.[4]

Katherine's volatile and intense temperament almost decreed that she should fall in love seriously during this period. Her love affairs, both the trivial and serious commitments, and those realized and unfulfilled, are significant as they contributed to

much of the content of the stories that deal with romance, courtship, and marriage. Her own sexual development was ambivalent. While she was completing her secondary schooling at Miss Swainson's School in Wellington, she had fallen in love with an exotic highborn Maori girl. The uncensored second version of her *Journal* reveals her passionate lesbian attraction to the young woman, named Maata Mahukupu:

I want Maata I want her—and have had her—terribly—this is unclean I know but true. What an extraordinary thing—I feel savagely crude—and almost powerfully enamoured of the child.

Although Maata, known also as Martha Grace, appears to have indulged her aggressive friend, there is no evidence that she reciprocated her feelings. The experience, from Mansfield's point of view, however, is significant, in that she was to touch upon the subject of lesbian love later in some of her stories, most notably in "Bliss," in which Bertha, like Katherine herself, finds herself falling in love with the exotic, remote, and passive Pearl Fulton.

During the period of her infatuation with Maata, Katherine involved herself with a pair of twins who grew up in New Zealand and eventually went to study abroad. She was drawn first to Arnold Trowell, a young cello virtuoso, and, always suggestible, she took up the instrument with the boy's father, Thomas Trowell. Her powerful longing for Arnold was to go largely unfulfilled, and when she returned home she engaged in a lesbian love affair with Edie K. Bendall, a somewhat older woman. When her father finally allowed her to return to London, she turned once again to Arnold, who had remained abroad to study and perform. Finally, in 1908, forced to accept his unequivocal rejection, Katherine transferred her romantic yearnings to his violinist brother Garnet, who returned her feelings. Her letters to Garnet are singularly frank in their sexual allusions. By 1909 she was pregnant by him but abandoned

under the deep displeasure of Garnet's father, who persuaded his son to disentangle himself from the high-strung and unconventional girl.

Motivated by the need to find a father for her unborn child, Katherine made an impulsive and loveless marriage with a professional singer named George Bowden, whom she left on her wedding day. The marriage to Bowden, eleven years her senior, was not consummated, and Katherine went to Garnet for an uneasy and ultimately unsuccessful reunion. Her mother, learning the unsavory facts of her daughter's personal life, sailed to London and placed her daughter in a spa in the Bavarian Alps for the duration of her confinement. The group of satires and sketches gathered together under the title *In a German Pension* are based on some of the "cure guests" the young woman met during her enforced lonely exile.

Toward the end of her pregnancy, which was complicated by the first signs of tuberculosis, the disease that would eventually kill her, Katherine gave birth to a premature stillborn child. She stayed on in Germany for a while and gradually entered into a series of love affairs, one with a Polish critic named Floryan Sobienowski, and another with an Austrian journalist identified in the *Journal* only by his initials S. V. When she finally returned to England in January 1910 she went back to the patient Bowden, agreeing to live with him as his wife. The reunion could not have been a success, judging from her portrait of Bowden in the unflattering "Mr. Reginald Peacock's Day," a cynical character study of a vain social-climbing voice teacher. When this experiment proved as dismal as her abortive liaison with Garnet Trowell, she left her husband for good two months later without troubling to file for divorce. Bowden himself took no steps toward securing his freedom until he wished to remarry eight years later.

This was a fateful time for Katherine. According to her devoted friend and lifelong companion, Ida Constance Baker, who wrote a memoir under the initials L. M. (for Lesley Moore,

the nom de plume Katherine had designated for her because she thought her own name too ugly, and because the new one reminded her of her dead brother), Katherine was once again pregnant, this time by a man named Francis Heinemann, who probably never knew about his part in the affair, and did not see his lover again for six years and then only when a chance meeting brought them together. As uncelebrated as this love affair was, however, it offered new grist for Katherine's mill, providing the basis for the bitter story, "The Dill Pickle." This time Katherine underwent an abortion.[5] The period marks the onset of her precarious physical condition, for from then on she was never to be entirely well again. She had had an operation for peritonitis of gonococcal origin just prior to the abortion, and was probably rendered infertile from then on. She suffered her first attack of "pleurisy" at that time, although in retrospect it seems more likely the early onset of tuberculosis she contended with. She was to suffer recurrent attacks of rheumatism and a failing heart for the rest of her life, driving her from one cure to another, and from the mountainous sanatoriums of Switzerland to the warm climates of southern Italy and Provence for healing. Stories such as "The Man without a Temperament" record these sad peregrinations with dispassion and fidelity.

After yet another lover, identified in her diary only as "the man," Katherine's impulsive and finally trivial relationships came to an end in 1912.[6] She met John Middleton Murry, who was to play the most significant role in her life until her death, not only as her lover and final husband, but as her mentor, confidant, editor, publicist, and eventual biographer. Murry, an intellectually gifted but weak man, born into a lower economic stratum than Katherine, was invited to move into her flat on Platonic terms two months after they met. When they became lovers a few months after that first arrangement, it was at Katherine's suggestion and seduction. At that time Murry was the editor of an avant-garde literary magazine called *Rhythm*, and had already published Katherine's story "The Woman at the Store"

and admired it inordinately before he met its author. Eventually Murry made her his coeditor, and the magazine remained the focus of their joint lives until it failed in July 1913. The distinguished but short-lived monthly ran only a total of fourteen numbers and then struggled along under the title *Blue Review* for three more issues, containing in its final edition pieces by Mansfield, D. H. Lawrence, who was a regular contributor, H. G. Wells, Hugh Walpole, and the poet Rupert Brooke. T. S. Eliot was an occasional contributor during the magazine's lifetime. Katherine persisted in thinking of him as a fiction writer rather than a poet because as she saw it "The Love Song of J. Alfred Prufrock" told a story.

Although Katherine and Murry did not marry until six years after they met, by the time they decided to take the step she was already seriously ill with tuberculosis. Their marriage became a migratory affair, with Katherine seeking one haven after another in pursuit of an increasingly elusive restoration to health. The bulk of Murry's time with his wife was marked by increasingly long absences from her, during which periods Katherine journeyed to Cornwall for the sea air, to Ospedelatti and Menton on the Italian Riviera, to Switzerland for purer oxygen, and finally to the Gurdjieff Institute in Fontainebleau, which dispensed a species of faith healing by a hypnotic Russian mystic. The long absences from Murry were punctuated by intense correspondence, marked by longing on her part and frustration on his. Privately he confessed: "She knew, just as well as I, how ill she was; yet she expected our marriage to work the miracle. . . . The memory of my wedding to Katherine is a memory of the *anguish*, not the happiness of love."[7]

Although Katherine's illness became the prepossessing concern of her last years when her recurring symptoms no longer allowed her to deny its inexorability, her writing continued to draw attention and recognition. Even before she signed on as an editor of *Rhythm*, she had received strong encouragement from A. R. Orage, the Fabian editor of the weekly *New Age*. As early

as 1910 Orage had published her story, "The Child Who Was Tired," a story powerfully inspired by, and some say copied from, Chekhov, whose work she first began to read while she was at the Bavarian pension. In rapid order Orage published nine more of her stories, and although he was later to write a vicious denunciation of her when she left him for *Rhythm* he published six more of her stories in 1911. Her first book, *In a German Pension*, was well received by the *Manchester Guardian* and *Athenaeum*, and went into a third printing. The now-celebrated "Prelude" was laboriously handprinted and bound by Virginia and Leonard Woolf's Hogarth Press.

In 1919, when Murry moved on to become the editor of *Athenaeum*, Katherine was appointed to the position of fiction critic for that prestigious publication, all the time continuing to turn out stories, among them the highly regarded "Miss Brill" and "Sun and Moon." Her reviews were collected in a volume called *Novels and Novelists* and were published posthumously by Murry. Although by 1920 her hold on life was tenuous, one lung having been destroyed by disease, she wrote the ambitious "Je ne parle pas français," supposedly motivated by her ongoing distaste for the French among whom she frequently convalesced, and "The Man without a Temperament," a fictionalized account of her dependence on the impassive Murry during her frequent Mediterranean sojourns.

In spite of her declining vitality, Katherine translated Chekhov's letters from the Russian and wrote poetry under the pseudonym Elizabeth Stanley. Her growing reputation drew the notice of the influential and wealthy art patrons Sydney and Violet Schiff, who published two stories in their magazine *Arts and Letters*. The *Nation* took "The Life of Ma Parker" in 1921, and the *London Mercury* ran "The Daughters of the Late Colonel" in that same year. Clement Shorter, the editor of *Sphere*, contracted for six stories. The list was a distinguished one, comprising "Mr. and Mrs. Dove," "An Ideal Family," the inspired sequel to "Prelude" called "At the Bay," "The Voyage," "The Garden Party," and "The Doll's House," all completed in 1921.

In 1922, her third collection, named for the story that was to become her most widely anthologized piece of fiction, was published by Constable under the title *"The Garden Party" and Other Stories*, and underwent a third printing within three months. Such reputable critics as Rebecca West of the *New Statesman* and Joseph Wood Krutch in the *Nation* praised her growth as an artist and the polish of her prose. It is obvious that her disease, which worsened dramatically, failed to halt her creative pace. In fact, possibly feeling time's winged chariot drawing near, she completed the story "Taking the Veil" in three hours on January 24, 1922. On July 7 she finished her last complete story, "The Canary," and made her will on August 14.

From that time, Katherine spent her remaining months seeking new paths to recovery. At the suggestion of her old friend Orage she began to investigate the Institute for the Harmonious Development of Man, a center for nondenominational faith healing founded by a hypnotic Caucasian of Greek descent named George Ivanovich Gurdjieff. This self-styled Guru was sufficiently persuasive to have attracted a mixed bag of disciples who had been converted by Gurdjieff's chief spokesman, the journalist P. D. Ouspensky, whose book *Tertium Organum* was the vehicle for the synthesis and dissemination of the Institute's complex philosophy. Despairing of physical cure, Katherine joined the faithful of the Ouspensky circle in the hope of achieving through psychic healing what medical science could not accomplish. In a desperate final move she entered the Institute, which was located in an abandoned Carmelite monastery in the forest of Fontainebleau and died of a massive lung hemorrhage on Tuesday, January 9, 1923. Murry was with her at the time.

The New Zealand expatriate was buried on French soil, as was her beloved brother Leslie. The inscription on her tombstone was taken from Shakespeare's *Henry the Fourth*, part 1, act 2, scene 3: "But I tell you, my Lord fool, out of this nettle, danger, we pluck this flower, safety." Katherine, who created some of her own danger but was surely victimized increasingly by her own unfortunate circumstances, did not in the end succeed in plucking that prized but elusive flower.

2

The New Zealand Cycle: A Bildungsroman

The New Zealand stories, taken as a whole, make up Katherine Manfield's *"Bildungsroman,"* or novel of growth, from childhood to maturity, from artist-in-the-making to mature practitioner of her craft. The stories paint a portrait of the artist as a young person, similar to, if less focused than, the portrait of the young James Joyce disguised as Stephen Dedalus in *A Portrait of the Artist as a Young Man*.[1] Mansfield's fictionalized retrospective accounts of her life in the New Zealand stories contain many of the elements that preoccupied her great Irish contemporary: the love-hate relationship with her native land from which she had long been in self-imposed exile; the tender yet conflicted love and resentment inspired by her powerful (though vulnerable) father; the affectionate but unsparing eye directed toward family and friends; and the shaping influence of school, companions, and cultural environment. In Mansfield's sprawling "novel" of development—composed of dozens of stories and vignettes of varying length and polish—the reader is confronted by an intuitive, often morbidly sensitive participant-observer who is a product of her nurture and a rebel against it, growing into her individuated self yet never freeing herself entirely from her shaping background, nor, in the final analysis, wishing to be separated from it.

This type of recorder and interpreter of experience is familiar

13

enough in literature, from Thomas Mann's Tonio Kröger and
D. H. Lawrence's Paul Morel to the American Augie March in
Saul Bellow's picaresque chronicle of adolescence and J. D.
Salinger's Holden Caulfield. The tortuous journey from child-
hood to adulthood in Mansfield's account is meticulously re-
corded through a number of personae, beginning with the small
Kezia Burnell, and continuing through other members of her
family—sometimes simultaneously—who are then transmuted
into another family, the Sheridans, representing Mansfield's own
Beauchamp family at a later stage of her life. The New Zealand
setting is as essential and as compellingly recalled as Lawrence's
mining town of Eastwood, Joyce's Dublin, and Thomas Wolfe's
Asheville in Look Homeward, Angel. What sets Mansfield's com-
plex memoir apart is not only its fragmentation into a great many
short stories, but its clarification and orderly presentation. The
early conflicts and unresolved rages are harmonized and
smoothed out in the author's affectionately drawn recollections.
Shape and meaning are given to the childhood years that pre-
ceded her chaotic periods of travel and study, her unhappy love
affairs, and her precarious health. The New Zealand stories glow
with tenderness and give off a luminous gleam of the preserved
and cherished past.

Mansfield's method in these stories involves the classic tech-
niques of the bildungsroman: selected and dramatized flashback
episodes often distorted for the purpose of highlighting certain
shaping influences; re-creation of key characters who appear and
reappear in various guises but are always recognizable because of
their distinguishing marks; and recurring symbols, similar to the
"leitmotifs" of Wagner's music and Mann's fiction, whose repeti-
tion recalls each previous occurrence, and which unify the work
in terms of its theme. In the New Zealand stories, as in all
internalized narration, powerful emotions are associated with
trees and flowers, ornaments of clothing, and sensory stimuli.
The universal experiences of childhood—fear, loneliness, and
self-consciousness, along with the warmth, interdependence,

and stability of family life—are recalled through appropriate
symbols, accompanied by the distinctive isolating awareness of
the burgeoning artist who stands apart from the child in whose
body she is coming to life. The child accepts; the artist rejects.
The child absorbs; the artist assesses. The child internalizes and
prospers; the artist places in perspective and denies herself the
very aspects of her environment that the social part of her trea-
sures.

 Ian Gordon, in his biography of Katherine Mansfield, ob-
serves with accuracy that "to a degree almost unparalleled in
English fiction [she] put her own experience into her stories. She
wrote of nothing that did not directly happen to her, even when
she appeared to be at her most imaginative and fanciful. . . . Her
whole work . . . emerges as a kind of *recherche du temps perdu*, a
remembrance of things past in a distant dominion." When the
stories are arranged, not necessarily in the order of their composi-
tion but in their chronology, they represent an almost unbroken
line of development. They trace the child's maturation into the
adult, the artist's awakening power to transmute what she has
instinctively felt into art, and the shaping of her chronicle of self,
family, and home.

"Prelude"

In a letter to Richard Murry, her brother-in-law, Mansfield
characterized "Prelude" as a story that "just unfolds and opens."
It begins, as do many of her narratives, "in medias res," in this
case a moving day for the Burnells. Like Mansfield's own family,
the Burnells are leaving their house in town for a larger establish-
ment in the country. The single male of the family is Stanley
Burnell, a prime evocation of the "pa man," a name the author
was to use often to describe a certain kind of male modeled after
her paternal grandfather and father. He is a type—domineering,
protective, blustering, and withal vulnerable and emotionally
insecure in spite of his determination to establish himself as a

paterfamilias in the home and a power in the community. All the
other members of the family are female. There is Linda, Stanley's
lovely, delicate, and detached wife, burdened with too many
children whom she fears she cannot love, and fearful that she
will bear many more to her bounding and sexually demanding
husband. The mothering role has been taken on by the elderly
Mrs. Fairfax, Linda's mother and the affectional center of the
family. The third adult female is Beryl Fairfax, Linda's pretty,
young unmarried sister, who lives in her fantasies of being swept
up by a storybook lover, while she fears that her youth and beauty
will fade and wither in the wake of Stanley's whim of rustication.
The three little girls whom Linda has borne are Isabel, Lottie,
and Kezia.[2] Although the simple story of the moving day and its
succeeding two days is told from a variety of perspectives, Mans-
field chooses Kezia as spokesman for herself. To borrow a term
from Henry James's fiction, Kezia becomes Mansfield's "center of
sentience" in much the same manner as does Morgan Moreen in
"The Pupil" and Maisie Farange in *What Maisie Knew*.

Marvin Magalaner finds "Prelude" and its sequel "At the
Bay" puzzling with respect to their author's intention: "What
these short stories have to say has eluded critics since their
publication."[3] Taken from one point of view, there is merit in
Magalaner's puzzlement. The events appear to have little signifi-
cance or even coherence in shaping the child's emerging
character or philosophical bent, perhaps because the author does
not dwell on any of the twelve brief episodes and offers no word
of explanation to illuminate their meaning. No single moment
carries any more weight than any other. But to the reader familiar
with Joyce's method in *Portrait* of presenting a montage of sense
impressions internalized by the very young child, the small
Kezia's kaleidoscopic reaction to the piled-on fragmentary signals
associated with leave-taking, uprooting, fear of abandonment,
and imperfect assurance in a strange setting will be plausible and
self-explanatory. The reactions of the child and the awakening
artist are presented simultaneously. The children's eyes are

"round and solemn" in the face of their impending departure from a familiar home, but they clasp hands for comfort. Their mother's rather cruel little joke about abandoning them because the buggy was filled to the brim is balanced by Kezia's sensory response to their neighbor's reassuring warmth. It is the artist Kezia, not the child, who imagines the neighbor as enveloping the children "like a huge warm black silk tea cosy." Whereas the ordinary reactions of childhood are conveyed through Lottie, who is weeping as all children will at the sight of the retreating familiar family, extra awareness of the moment is attributed to Kezia, who notices through her own tears the ludicrous contrapuntal sight of her kindly hostess's trailing pink corset strings protruding from her unfastened skirt. Small as she is and unformed as her intellect is, Kezia is a receptacle of opposing impressions, which she then translates into a fusion of tears and laughter, affection and disgust, daring and terror. She gathers experience and hordes it like a treasure away from prying eyes. When she is tormented by the rude and rowdy small sons of her hospitable neighbor, she pretends not to notice but secretly admits that she hates boys. Although she ignores their teasing and pinching, a single tear does roll down her cheek, but always on guard to protect her emotional privacy and disguise her vulnerability, she catches the fugitive tear "with a neat little whisk of her tongue" and eats it before she is found out.

Kezia and Lottie are contrasted further in the succeeding episode for the purpose of differentiating the artist from other people. Alone for a few final moments in the empty house, Lottie is important and protective as is proper in an older sister, but Kezia prowls the echoing rooms, noticing things. She observes the remnants of family life with an arranging eye. Bits of detritus come to life in "the long pencil rays of sunlight" that gleam through the slats of half-drawn blinds. Ordinary and familiar objects, subjected to the scrutiny of the child-artist, take on a surrealistic cast as Kezia squints at them through the colored glass of the dining-room window. The lily lawn is variously blue

and yellow to the child moving from pane to pane. In the garden Lottie is transformed into an alarming little Chinese sister to Kezia, who is peering at her from behind a smoky pane. In this episode the child's natural curiosity merges with the artist's creativity to transmute real objects into fearful fantasy. Overwhelmed finally by the terror she has herself induced through the vitality of her own imagination, Kezia flees from her former home where she now senses a dark shadowy "IT" is lurking. Unnerved by her imaginings, she remains wakeful and quaking through much of the long trip. Her unimaginative sister sleeps soundly.

Fear is a powerful motif binding the episodes. From Kezia's fear of abandonment and her subsequent nervousness at being lunged at by the rambunctious neighbor boys, Mansfield continues the theme of recoil from attack and withdrawal from confrontation. In the third episode, during the trip in the dark, the small child presses close to the storeman's comforting bulk. Coming into unfamiliar country, she asks questions about rural life and learns the difference between rams and sheep, namely that "a ram has horns and runs for you," which intelligence elicits from Kezia a confession that she hates "rushing animals like dogs and parrots," this last being ironic because at this time she does not yet know that the hall wallpaper will be covered with decorative parrots. She frequently dreams about fantastic animals charging at her, and "while they are rushing their heads swell enormous." Here Mansfield is using the still-uncomprehending Kezia as a bridge between natural childhood fear and the realized sexual anxiety experienced by her mother and translated into equivalent metaphors of swelling. When "Prelude" draws to its conclusion and the pattern that the author has been working is complete, one major motif in the overall design is seen to have been present from the start. In this intricate tapestry of family life, the thread connecting Kezia, the rejected daughter, and Linda, the remote mother, is strong and apparent. In this narrative the child is mother to the woman, linked to her by common anxieties and shared metaphors.

Swelling, with all its phallic and generative implications, is a major precipitant of Kezia's fears. She does not know it yet, but her shrinking from the attacks of boys and rams is a prelude to Linda's fully articulated and realized repugnance. In episode 5 Linda dreams that she has rescued a fledgling fallen bird. Stroking its minute head, she is alarmed to see it begin to swell, growing larger and rounder and finally swelling to such enormous proportions that she must drop it into her lap. The dream turns into a nightmare as the bird becomes "a baby with a big naked head, and a gaping birdmouth, opening and shutting." Waking, Linda discovers her husband naked on the rug and doing his setting-up exercises. He reminds her of "a big fat turkey" and she tells him so. Her fear of Stanley, his sexual swelling and her procreational swelling in her succeeding pregnancies, makes her wish that she were leaving, "driving away from everybody and not even waving." A little later that morning Linda traces the outlines of a poppy on her bedroom wallpaper, idly following its shape:

A leaf and a stem and a fat bursting bud. In the quiet, and under her tracing finger, the poppy seemed to come alive. She could feel the sticky, silky petals, the stem, hairy like a gooseberry skin, the rough leaf and the tight glazed bud. Things had a habit of coming alive like that. . . . But the strangest part of this coming alive of things was what they did. . . . They seemed to swell out with some mysterious important content.

Just at that moment, in another part of the house, her daughter and double, Kezia, had just retreated from a doll-filled buggy her sister Isabel was offering her for mothering and possibly some "light and menial duty." But Linda cannot skip away. She can only withdraw into aloofness and private fantasies of escape and regression into childhood. Instead of caring for her own children, she sits wrapped in a shawl and tended by her aging mother, or combing the hair from her mother's brow and thinking she could

not get along without her. She is her mother's dependent child just as surely as her own three children are.

Symbolic of the elderly Mrs. Fairfax's maternal function is the brooch she wears: a crescent moon with five owlets representing Linda, Beryl, and her three granddaughters. It is she who puts order in the kitchen, stocking it with preserves and other homely emblems of household thrift and plenty. It is she who makes the necessary concessions to her son-in-law's comfort. She embodies the female principle of nurturing, freed by her age from the burdens of sexuality, and made wise and tolerant by her own losses and her comprehension of her total dependency on Stanley, the acknowledged provider for her large extended family and its most misunderstood member.

Through the character of Stanley Burnell, the reader begins to see that Mansfield's images are chosen to present an intricate tapestry of family life in the midst of which each character is made to feel his own isolation as well as his belonging. He is seen in a brief vignette surveying the nursery in the new house, which has been made welcoming and homelike by Mrs. Fairfax, the resident household goddess. Under the mantel, which holds a jar of mixed wildflowers, sit his little girls eating bread and butter. But oblivious to these reassuring symbols of harmonious family life, Stanley thinks dark dissatisfied thoughts about the male heir he has not got. Also to Stanley's discredit, although he is entirely unconscious of his defect, is his importunate and insensitive devotion to his frail wife. Privately Linda indulges her ambivalence toward her husband with breathtaking honesty: "For all her love and respect and admiration she hated him," particularly after his vigorous bouts of strenuous lovemaking, when he was most grateful and eager to serve her. In his leaping to fulfill every minute wish of hers, he is ludicrous and distasteful to his wife. Like her daughter Kezia she fears lunging: "If only he wouldn't jump at her so, and bark so loudly, and watch her with such eager, loving eyes. . . . She has always hated things that rushed at her, from a child." In her impotent rage, Linda confuses her

husband with her Newfoundland dog, whom she loves to play with, but only in daylight.

Resignation, not resolution, is the preponderant solution to all the personal dilemmas posed in "Prelude." Linda resigns herself to her inevitable destiny as Stanley's wife and breeding machine. "I shall go on having children and Stanley will go on making money," she reflects. She compromises with her aversion to her husband's importunities and obtuseness in her reluctant appreciation of his slavish devotion to her and his generous, if demanding, support of her mother and sister. Privately Linda feels free to indulge in the luxury of admitting her ambivalent feelings about Stanley and about males in general, with the exception of her father, now safely dead and romanticized through her regressive childhood memories. Her ne'er-do-well and unthreatening cousin, the poetic and somewhat effete Jonathan Trout, is likewise exempt from Linda's aversion to the rampant male.

Linda's resignation mirrors that of her younger sister's. The pretty but peevish Beryl frets about her dwindling romantic prospects in the rural isolation forced on her by her absence of independent means. After toying with the idea of seducing the uncomprehending Stanley, who is both her provider and her jailer and thus deserves to be humbled, she pours out her heart in self-pitying letters to her distant girlfriends, lamenting her fate of burial in the country with no company other than the "louts" of local farmers. Finally, however, like her trapped sister, she takes stock of herself in the mirror and comes to terms with her "real self." Her narcissism is self-limiting. A serious confrontation with the looking glass reveals Beryl's beauty, her unfulfilled sexual appetites, and her vanity and selfishness. "Life is mysterious and good," she consoles herself and prepares to wait for the mystery to unfold while she preserves her integrity and compromises with her life's necessities.

Mrs. Fairfax, the household divinity, has learned compromise a long time ago. Calm, soothing, almost supernal in her

wisdom about human limitations and the natural order of things, she is able to adjudicate, to pour oil on the troubled waters of her daughter's disorderly household, and to transcend as well as calm its tensions. She brings Stanley's slippers, fries his chops, and preserves his illusion about his dignity in managing his affairs while she is actually the force behind his unstable throne. She recognizes his hideous taste in art, but dusts the frames carefully and hangs the paintings in obscure passages where they will not offend the sensitive Beryl. Knowing that Linda will not look after her children, she accepts the burden of rearing them without demanding a commensurate reward. She seems to be part and parcel of the dependable cycle of nature. When Linda asks her what she is thinking about during a stroll through the lush gardens surrounding the house, she replies calmly, "I haven't really been thinking of anything. . . . There are splendid healthy currant bushes in the vegetable garden. I noticed them today. I should like to see our pantry shelves thoroughly stocked with our own jam." Her visions are those of bountiful nature itself. And she is prescient as well as nurturing. Only she knows instinctively that the aloe is going to flower during the coming year, although that extraordinary event takes place only once in a hundred years.

Even the small prerational Kezia is capable of compromise. The clearest and most dramatic instance of life-preserving resignation is also the most celebrated among all Mansfield's vignettes. In episode 9, Pat, the Irish gardener, decapitates a duck for dinner while the Burnell girls and the little Trout boys, their cousins, look on. Kezia watches with stupefaction as the headless body waddles towards the pond. The little boys are madly excited by the morbidly fascinating phenomenon, but Kezia, hysterical at the sight of "the long spurt of blood where the head had been," charges the gardener and shrieks, "Put head back!" As Pat lifts the distressed child in his arms, her attention is distracted by an earring he wears in his pierced ear. "Do they come on and off?" she whimpers, and the episode is concluded. Kezia has not only been distracted, but she has also learned cruelty as part of the

daily practice of family life. That very night she will savor the beautifully basted duck with her siblings and parents. Further, because she is the artist in the making, she is more observant as well as more sensitive than the others, and draws an incomplete analogy from the two spectacles. The duck's head is permanently off, but the child's attention is drawn to the more acceptable version of the lesson, the earrings that come off but then may be put back on again. Safe in the arms of the murderer, she clasps her arms about his neck and hangs on for dear life. She absorbs the obscenity of the duck's appalling death and settles for her own safety.

The twelve episodes of "Prelude" are bound together and unified in their meaning by the overarching symbol of the aloe, whose significance may be gauged by the fact that the first and franker version of the story was named "The Aloe."[4] That Mansfield herself was enthralled by the aloe is recorded in her *Journal*: "The aloe is lovely. It fascinates me." She made it fascinate Kezia, Linda, and Mrs. Fairfax, who represent three successive generations of women reacting simultaneously to shared stimuli. Each responds to the plant in a unique manner, indicative of her level of emotional and philosophical development. Kezia is astounded: "Whatever could it be? She had never seen anything like it before." To the child, "the huge plant with thick grey-green, thorny leaves" surrounding "a tall stout stem" is merely mystifying. Her mother identifies the plant for her daughter, but for her it is something far more sinister. To Linda's eyes, the plant is phallic, perceived as "fat and swelling"; its stem is "fleshy." It is also cruel in its suggestive innate power. Its roots look like "claws"; "its blind stem cuts into the air as if no wind could ever shake it." The aloe's natural blind force drives it deep into the soil and shoots its generative member high into the atmosphere, binding together earth and air, flesh and spirit. The plant's regular and inexorable cycle of generation is a terrifying reminder of Linda's own burdensome fertility and her husband's irresistible sexuality. The aloe's mindless cruelty and durability,

its genital shape and loathsome "hiding" of something at the center of its tough and shielding leaves are emblematic of her love-hate conflict. She both fears and worships the plant, half shutting her eyes and smiling dreamily at it as it looms sphinxlike in the moonlight. "The curving leaves and blind stem" are, after all, ambiguous symbols. They not only suggest all procreational energy in its random force, but specifically the uncontainably energetic Stanley, on the one hand so practical and solid, so firmly rooted to the earth; on the other, so passionately bound to his delicate and mysterious wife and so easily daunted by her spiritually dominant nature.

Finally Linda smiles mysteriously as she informs the mystified Kezia that the aloe blooms only once in every century. She slits her eyes in a dreamy reverie in recognition of the secret she shares with the godlike plant. In an innate gesture of animism, Linda worships the force that ordains her human destiny. Her smile is a composite of recognition, resignation, and conspiracy. Most of all, it is an epiphany. The sudden spiritual manifestation inherent even in random objects or events is experienced as a moment of union between the plant and the woman. The mystical connection, rarely understood but deeply felt, is ephemeral, but for a single moment in the moonlight, Linda Burnell is, in terms made familiar by the famous debate on aesthetics in *Portrait of the Artist as a Young Man*, "radiant" in her insight into her oneness with nature.

The aloe holds no special mystery for Kezia's grandmother, who is past the years of childbirth, but remains the loved, almost ageless nurturing force in the household. The surging upright stem of the plant could also be her symbol of upright strength; its deep-rootedness her dependability to those dependent on her. Whereas to her daughter Linda the plant appears variously as a ship as well as a living thing—both as a symbol of the womb and as a vessel of escape—to the old woman it is simply a grand and cyclical emblem of natural rhythms. She *knows* what mystifies Kezia and thrills and terrifies Linda. Mrs. Fairfax is beyond

erotic fancy as well as unfounded fear. In an extraordinary moment of lustration, she and her daughter and the aloe are "bathed in a dazzling light." The old woman says, "I have been looking at the aloe. I believe it is going to flower this year." Like a sibyl, she knows, and communicates her prophecy to her daughter, who rejoins, " 'Do you feel it too?' in that special voice that women use at night to each other." At that moment, Linda, who has shunned the aloe, thinks, "I like that aloe. I like it more than anything here." The moment, like all epiphanies, comes and is gone, and in succeeding images, the thorns of the cruel aloe are conjured up as protective weapons against the invading Stanley, while the plant itself is metamorphosed into an escape vessel. But the experienced prophetess is correct. In the succeeding story, "At the Bay," Linda gives birth to "Boy," the heir Stanley has so fiercely demanded.

What then is "Prelude" about? Simply stated, it is an episodic account of a domestic upheaval and resettling, narrated to feature the various members of a family in a captured moment of awareness, conflict, and resolution. Its ultimate significance may very well be elusive on a certain level, as Magalaner suggests. But it shares with Wordsworth's evocative poem of the same name a preoccupation with the influence of the child's immediate environment upon his spiritual development. Mansfield's *Journal* establishes her thorough familiarity with Wordsworth, and she understood his emphasis on nature as the prime mover on the infant soul. In Mansfield's case, however, it is not nature alone, but the added forces of family and community, that shape the small Kezia. Mansfield further complicates and telescopes the shaping process by showing three stages of development simultaneously, all of which communicate a particular stage or point of view in the writer's own consciousness and level of development.

"At the Bay"

Mansfield knew that this sequel to "Prelude" was going to be difficult. She declared as much in her *Journal* as she was begin-

ning to wrestle with it: "At the Bay, with more difficult rela-
tionships. That's the whole problem." Kezia remains the center
of sentience in a number of episodes, but Beryl plays a more
significant role as the young woman awakened to her own sen-
suality and in conflict with her nature. Linda is again brought to
bed in childbirth and finds her unwilling maternity stirred in
response to her first and only male child. The grandmother
occupies an important place as she teaches a young child a lesson
in mortality.

The Burnell family is spending a summer at Crescent Bay, a
seaside resort of surpassing beauty. The tale that recounts their
adventures has a dozen episodes, as "Prelude" had, and a con-
trolling and unifying symbol. This time it is the sea. The very
first paragraph describes the sea at sunrise, and the last concludes
with the sea glittering in the moonlight. Between those two
bracketed extremes of the day, the sea is an unending presence
and the scene of a number of contests and dramas. As the
morning mist lifts, separating the sea from the meadow that runs
down to its shore, the first of a number of small human con-
frontations begins.

Stanley Burnell dominates the first episodes. He is the first
man "as usual" to plunge into the sea, challenging it as he does
every hurdle in his day, with exuberance and proprietary ag-
gressiveness. His position as king of the waves is dashed almost
immediately as he is waylaid by another species of manhood, one
not to his liking. Stanley, a go-getter himself, scorns failure, and
his cousin-in-law, whimsically named Jonathan Trout, is a fail-
ure, but he is there before him and has already swum out beyond
him. Stanley, who lives by the rule of the territorial imperative,
is vexed because his rival doesn't "stick to his part of the sea."
Jonathan, who naturally swims like a fish, is faster and sleeker in
the water, but Jonathan is a failure on land. Terra firma, where
the businessman Burnell succeeds, is terra incognita to Trout. In
the water, he can "carelessly, recklessly" spend himself, but once

out, the frail Jonathan is cold and miserable, no match for the earthbound Stanley.

The contest between Stanley and Jonathan Trout is mirrored by a parallel conflict between the little girls and the young Trout boys—or should one say Trout fry? The three sisters are sturdy and plump, but are fearful of the sea; the boys, delicate and spindly, plunge heedlessly into the waves, but after a few minutes of exposure, they shiver and turn blue, while the hardy little girls' caution protects them from harsh exposure. Indeed, self-preservation appears to be a controlling theme in this complex tale. The small sisters preserve themselves from the elements in their new environment just as they shielded themselves from the "savage" and predatory boys of their former neighborhood. The grown-up sisters seek likewise to preserve themselves from their natural enemies—mature sexually potent men—in somewhat more complicated ways. In all cases the battles have been joined in the sexual arena and are deadly serious. Survival, and even mastery, is at stake.

All the females in episode 3 are united in getting rid of the troublesome male in their midst. Having exacted his tribute of service from his wise and temperate mother-in-law, his resentful sister-in-law, and Alice, the truculent servant, Stanley dashes off to his office, frustrated as usual by his wife's dreamy inattentiveness and certain that his small daughters have made off with his walking stick. When his coach finally leaves, the women of the household are set free. They appear to float about weightlessly. "Oh, the relief, the difference it made to have the man out of the house. Their very voices were changed as they called to one another; they sounded warm and loving and as if they shared a secret." The secret they shared, of course, was not informational but emotional: an unexpressed but deeply felt, though varying, resentment of men in a prefeminist world.

While Stanley is away, Linda lies in a reclining chair under the flowering manuka tree, with her newborn son lying on the

ground beside her. She ignores the helpless baby and devotes her reveries to the past, a time when her father had proposed in jest that they escape somewhere, "two boys together." In turning the clock back to her prepubescent "boyhood" before she was to become sexually differentiated, and was still known by the tomboyish nickname "Linny," she succeeds for a few moments in obliterating her unwelcome wifehood and motherhood. Then the child turns and smiles at her and for a moment the mother in Linda is awakened. Her guard is lowered, and, her eyes welling with tears, she whispers an endearment to him just at the moment he turns from her, probably duplicating Stanley's behavior after he has aroused her emotions just at the point of his own satiety. For Linda it is an epiphany symbolized by the flowering manuka tree: "Why take the trouble to flower if the petals then fell over you and made a mess?" Reconcilement and rebellion are neatly fused in Linda's emotional ambivalence conjoined to her insight into her helpless flowering.

Beryl Fairfax, a major figure in "At the Bay," engages in her own contest with herself and comes out the victor after much backing and filling. Beryl is the polar opposite of her torpid sister. Yearning to be sexually assaulted and fulfilled, she puts herself in danger. Her unformed mind and her vanity are her worst weaknesses. They place her in peril in two overlapping arenas. Catching the eye of a "fast" and masculine woman, she permits herself to be flattered and wooed by this travesty of a female. Persuaded to undress before her, Beryl feels her own potential sexual allure for the first time under the appraising eye of the lean jaded older woman.[5] Immersed in her narcissistic fantasies, Beryl is persuaded to meet the woman's husband, a better-looking and more genuine temptation than his warped wife. When he becomes sexually demanding, the romantic and virginal Beryl recoils. His seductive smile has been transmuted to a hideous leer, and the uninitiated Beryl, all alarms ringing, pushes off the "vile" male interloper and escapes. Mansfield concludes the episode with an

analogy from nature: "In that moment of darkness, the sea sounded deep and troubled."

The story is carefully planned and composed. One notes its unity. It begins at sunrise and ends in moonlight. The opening and concluding phrases contain three words each: the first, "Very early morning"; the last, a complete, if minimal sentence, "All was still." The first fragmentary phrase plunges the reader into the middle of things, a Mansfield trick that conveys the energetic mood of a day already in full swing. The last three words draw the curtain. The sentence is complete because the action is over. What has been accomplished has been recorded. The males and females have striven and contended. Losses have been sustained and compensated; what victories there were have been hard-won and instructive. Although men have been much in evidence in these episodes, the reader is not afforded insight into what these men have learned from their experience. The women, on the other hand, have been considerably enriched and enlightened.

Learning in "At the Bay" begins in earliest childhood and ends in maturation. In episode 7 the small Kezia learns about death from her grandmother, whose serenity in the face of her own impending end is unacceptable to her granddaughter. During an afternoon siesta the two share a reminiscence about the death of old Mrs. Fairfax's son. For Kezia this is the stuff of legend, until she discovers that her grandmother too is not immortal. The old woman tries to persuade the child to accept the inevitable, and then the two of them forget in a reassuring game they play before they both fall asleep. The episode is balanced with great delicacy against the vignette exploring Linda's reluctant flowering and her acceptance of her inexorable function. Her teasing affectionate banter with her beloved improvident cousin Jonathan Trout also bears out the theme of transiency and aging. Linda notices that Jonathan's hair has become speckled with white, as he kneels before her in a mock-chivalric pose. He is everything Stanley is not: sensitive, gallant,

playful. Yet he is marked for early decrepitude, just as the sturdy striving Stanley is surely marked for longevity. Thus mother and daughter learn about frailty and inevitable death in two contiguous episodes.

As the aloe is a multifaceted symbol in "Prelude," the sea is an encompassing emblem in "At the Bay." It ebbs and flows as the life in the Burnell household ebbs and flows. Beryl stems the tide, whereas Linda lets it wash over her. The little girls retreat from the pounding waves, while the boys, training for their ultimate male roles, plunge in daringly while shivering and shaking. The sea reflects the rhythms of life, in contrast to the sun, which symbolizes danger. Old Mrs. Fairfax explains to Kezia that her son died of heatstroke. Linda stays out of the sun just as she tries to avoid her husband's sexual heat. The little girls are taught to wear sunbonnets by their grandmother, who herself wears a protective headkerchief. The lesson is intended as a contrast to Mrs. Harry Kember, Beryl's unsavory friend, whose leathery sun-browned face renders her decidedly unfeminine and unappetizing. The energizing sun is to be avoided, whereas the sea shelters and cradles Beryl as she bathes. The sea is mutable, appearing to mirror the temperaments of the individuals, whereas the sun sends out rays of unmitigated force, often malignant. Only at the end of the day, when the sun has gone down, does peace prevail. For then, at sunset, "no sound came from the sea. It breathed softly."

What is "At the Bay" about? Just as "Prelude" seems to be about a brief period of transition set into motion by a household move, "At the Bay" seems to be about a daily bathing by the Burnells and their friends, interspersed with respites of easeful summer activity and idling. On a deeper level, "At the Bay" may be said to answer some of the questions that "Prelude" poses. Linda's tentative question "What will become of me?" in the first story is answered definitively in the second. She has borne Stanley the heir he has demanded and discovered her own latent maternal love, ephemeral as it may be. The aloe, which was

refuge, trap, and escape vessel to Linda in the first story, has vanished and been replaced by the eternally flowering manuka bush. Stanley has also changed. Having left the house in a huff in the morning, he has returned in the evening contrite and fearful that he has offended his beloved Linda, something he was incapable of in "Prelude." Kezia is no longer running so determinedly from life. In "Prelude" the final episode offers a glimpse of Kezia running away "airily" from some small domestic infraction she has committed. In "At the Bay" she stays put in the comfort of her grandmother's bed and shows some readiness to absorb the realities of life, and in particular, death. But the greatest change takes place in Beryl, Mansfield's intermediate persona, who is poised midway between the impressionable Kezia and the experienced grandmother. At the beginning Beryl is malleable clay—young, imperious, sexually curious but unawakened. The haughty young woman comes close to humiliation at the end of "At the Bay," but she also approaches some self-understanding in the act of pushing the leering Harry Kember from her. Although she runs at the end, she is running to save her life, not away from it. Snobbish and intolerant in both stories, the Beryl who chides the servants, scolds the little girls for breaches of manners, and expresses her contempt for Stanley's taste in art while she considers seducing him to satisfy her vague unformed sexual itch, is brought to her knees and to her senses through her own vanity.

Beryl's lesson is the most significant in the entire story. It is no accident that Mansfield places her episode at the end of each story, just as it is no accident that she names her after a semi-precious gem that is prismatic in nature. In the last scene in "Prelude," Beryl asks herself some unanswerable questions, among them: Would she always be nothing more than a false self, an unsubstantial shadow? Because she is untried and untutored, the mirror gives her back no answer. In the final scene of "At the Bay," she forces the frustrated Harry Kember to ask the ultimate question. First encouraged and then repulsed by a Beryl suddenly

alert to danger, he is reduced to stammering: "Then why in God's name did you come?" But Beryl, who has discovered at the brink of her intended folly that he is "vile," eludes her seducer and saves herself. She has begun to know something and is on her way to maturity. Sensing danger, she is able to wrench free of the romantic yearnings generated by her self-absorption. The sea, "in that moment of darkness, sounded deep and troubled," reflecting Beryl's dilemma. It also voices the pain she feels, the first real pain induced by self-examination after a protracted adolescence of self-immersion, fantasy, and endless mirror gazing. If Beryl has not yet established a real identity to supplant her juvenile false self, she is nonetheless on her way. The final phrase, "all was still," is emblematic of the stilling of Beryl's emotional turmoil and the beginning of her coming to terms with herself.

If "Prelude" and "At the Bay" are two parts of a bildungsroman, much as J. D. Salinger's *Franny* and *Zooey* are, they are far more economical and certainly less discursive. Some episodes are merely montages of fragmentary events and observations. They show all the stages of growth and development at the same time in the same household. Each member of the family represents a specific stage of life; in addition, the female characters symbolize different stages of the same person interacting with each other in harmony and conflict. Kezia, Beryl, Linda, and Mrs. Fairfax are different aspects of Mansfield herself, artist and woman, real and imagined. In Kezia, Mansfield portrays herself as different from her more conventional sisters; in Beryl, Mansfield envisages herself as more isolated, insecure, and frustrated than her socially integrated friends in Wellington; in Linda, the artist creates yet another image of herself as unwilling wife forcibly removed from her true self and made to bear a domestic burden, while she would much rather dream of the past and escape into her own future. The old Mrs. Fairfax is the woman Mansfield would devoutly wish to be in her old age: loving, beloved, wise, and fully integrated in female function and fulfill-

ment. A further complication is the fact that each of the portraits is also a faithful representation of Katherine as a child, her mother, her aunt Belle, her sisters, and her grandmother.

At the end of the two-part group portrait, the characters have demonstrated a rich and complex psychological credibility owing to the alternation of action and inertia the author has invested them with. Beryl, who has been passive and nearly paralyzed in "Prelude," takes action in "At the Bay," and willy-nilly, begins to move on by daring to meet, and even instigate, temptation. Linda, who in "Prelude" urges Stanley at times to clasp her and eludes him at others, finally bestirs herself from her torpor in "At the Bay" and notices her son, yielding, if only for a moment, to her maternal instincts. The three little girls have been evoked in all their fears, incapacities, and rivalries. It would appear that the entire purpose of this dense fictional biography may be to consider Mansfield's sly answer to the rhetorical question Linda asks while she idles away her hours under the manuka bush: "Why be born at all?" At the end, although the reader has been given no clear-cut answer, Mansfield has succeeded in suggesting a good many subtle reasons, none of them definitive but all provocative, for being born and seeing life through.

"The Little Girl"

The recollected "wrongs" of upbringing and their attendant childhood sorrows have contributed enormously to literature in general and to fiction in particular. Novelists such as Dickens in *Hard Times* and biographers such as Edmund Gosse in *Father and Son* have dwelt with some obsessiveness on the conscious or unwitting cruelties perpetrated on hapless children by their larger-than-life parents. "Don't think I underestimate the enormous power parents can have," Mansfield wrote in one of her letters. "I don't. It's staggering, it's titanic. After all, they are real giants when we are only table high and they act accordingly. . . . We have to find the gift in it." One wonders what the "gift" is in

some of the powerful episodes recorded in literature: Stephen Dedalus's horror at seeing his father burst into passionate tears at the ruined Christmas dinner; or Lawrence's stunning narratives of brutality visited by his miner father on his children before the eyes of his embattled wife in *Sons and Lovers*, his thinly disguised autobiography. Lawrence, like Joyce in A *Portrait of the Artist as a Young Man*, did manage to find the gift through hindsight, and lived to forgive his father. The callousness and self-indulgence of parents are redeemed and actually defended if the child lives long enough to place his parents' behavior in perspective, and if the child becomes an artist as Mansfield and the others in question did, eventually rewarding them through their art.

In the story, "The Little Girl," Mansfield uses Kezia once more as the center of sentience in this affecting narrative of a child's limited perspective. The author begins as usual in the middle of things, without troubling to set the scene through a clarifying introduction: "To the little girl he was a figure to be avoided and feared." Mansfield readers are familiar with the collective relief expressed by the female members of the household upon the departure of the provident male each day. Now the arena is emptied of all but the mother, the father, and the shy little Kezia. Her father's voice is loud, his manner peremptory. Kezia stutters, as did Mansfield herself, when her father addresses her. He is insensitive. He scolds her for her wretched appearance and her slovenly dress. He declares her hands "jog like an old lady's" when she is accorded the honor of carrying his tea. His list of offenses to the child's delicate sensibilities is impressive.

After the first two pages, the reader begins to suspect that the story is unexpended capital, that it will not be invested in a stock that might yield higher returns than a record of recollected personal grievances. But just at the moment of greatest danger in the ongoing litany of abuses, Mansfield breaks free. She does not after all yield to the temptation of wallowing in the memory of personal injury. The story takes shape. The child is whipped for a thoughtless act she has committed in the service of a thoughtful deed. She has torn up her father's important speech for the

purpose of making a filler of scraps for a pincushion intended as a gift for his birthday. It is a moment of supreme trauma. For a long time she is unable to see her father without whipping her two beaten hands behind her back. At the same time she observes her neighbor's children taking liberties with their indulgent father that she dare not with hers. In one of Mansfield's minor epiphanies, Kezia decides at that moment "that there were different sorts of fathers." If the story had ended there, it would have belonged to a great many other similar vignettes Mansfield had left in various stages of completion, all drawn from similar childhood memories. But this time she brings the story to completion with a twist of plot. With her ailing mother away and her comforting grandmother unavailable to her, the child is visited by a familiar nightmare. Her father responds to her need with love and a satisfactory male comforting that eclipses the ministrations of her female guardians. The child experiences another epiphany, a swift montage of impressions that she is too immature to sort out: her father's tiredness; his hard work that prohibits clowning about with his child in the manner of his improvident neighbor; his abandonment by the two resident females in his life; the sense that in bed with his arms shielding her, he was not so monstrously big after all. For the moment the roles are reversed as the child breathes compassionately, "Poor father!"

It is a slight story but intensely recalled. The narrative gains its momentum from its recollection of an event in tranquillity. It is also a perfect evocation of the "pa man" central to Mansfield's girlhood and so dominant a theme in her fiction. The vulnerability and assailability of the authority figure in the author's own life is brought squarely into focus from the limited vantage point of the small child, but it is told with tenderness by the young writer who succeeds in keeping the two antagonists firmly in perspective and is fair to both.

"New Dresses"

"New Dresses" is a far more penetrating and less forgiving story. Although the characters are disguised this time as the Carsfields,

not the Burnells, it is the same family, her own under scrutiny. This is a narrower, ungenerous evocation of the "pa man," less prosperous materially and lacking in compassion. He is the "pa man" on the way up, equipped with a long-suffering wife and a new son, whom he proudly calls "Boy." There are two daughters, one docile, the other rambunctious, and the ubiquitously loving grandmother. All the familiar elements of Mansfield fiction are present, but the deck is more patently stacked. The "ficelle" here is Helen, hoydenish and unmanageable, a stutterer like the fictional Kezia and the real Katherine. The story is gripping, more for the light it sheds on the troublesome young person who will not fit into the conventional mold than for any subtleties of character. Whereas in "The Little Girl" Kezia stands on her own as an affecting, well-intentioned little creature, here she is insensitive and almost as unattractive as the tractable sister with whom she is invidiously compared by her parents. One suspects this is, in fact, a more accurate portrait of the author herself during her formative years. Although her sister is entirely praiseworthy from the world's point of view, the reader is told that Helen is superior because she is an artist in the making and therefore entitled to be eccentric, literally "off center." As in Mann's "Tonio Kröger," in which the young Tonio is contrasted with the Teutonic Hans, Helen is the departure from the type.

The inconsequential issue from which the conflict emerges is a slight but predictable female dilemma. The mother has been extravagant in her purchase of some cashmere for her daughters' Sunday dresses and then is driven by fear and guilt to hide the truth from her mean-spirited husband. The argument is skewed through Mansfield's highly charged preference for the downtrodden and rebellious female and her active distaste for a certain kind of rigid male. It is a classic "we-they" struggle, with no pretense of fairness on the author's part. In order to portray the "we" in a favorable light, Mansfield is reduced to creating a caricature of a man. She accomplishes her purpose in a few deft strokes. Whereas the worn-out mother "drops" into a chair with

fatigue, the father "storms" over the bills, picks his teeth, "slams" the account book onto the table. The mother is all put-upon, the father all ruthless bullying. The grandmother, as usual, is full of insight and near-saintly forbearance. Mansfield's prejudicial verbs depict the male's unheeding force with devastating impact, but the character is too stark and thus less credible than her other imperious yet vulnerable "pa men."

There is a touch of Ibsen in this story, a suggestion of the domestic dynamics in A *Doll's House*. Henry, the obtuse and self-satisfied husband, treats his wife in one scene much as Helmer does Nora in his expansive mood. He bounces her on his knee and asks what she has been up to. His wife, Nora-like, dissembles in her most disarming and mock-ingenuous manner. She evades, flirts, wheedles, and plays with a button on her husband's coat in a manner reminiscent of Nora when she sits on Helmer's knee making squirrel noises and charming him out of a few dollars for her urgent private needs.

The females in this story are humiliated by a single dominant male, but towards the end Mansfield reverses the simplistic reductionism of "they" against "us" established at the outset. The blustering father is balanced by the family physician, who appears to understand the "special" nature of the family rebel. The wife, it develops, is no paragon. She is as sharply critical of her wayward tomboy daughter as her husband is, and as nearsightedly admiring of her vapid conventional daughter as he is. The dichotomy between nature and nurture is not expounded tiresomely but is deduced from the behavior of the two sisters. Rose, the family favorite, is a triumph of conditioning, whereas Helen, to quote Lear, is "the thing itself," a species of "unaccommodated nature." Defying the family's ban on play on the Sabbath, she swings high on the backyard swing, snags her expensive and controversial cashmere, and compounds her crime by hiding it and blithely lying about it. Impenitent and rude, she defies all and turns to the richer resources of her inner life. She is the midpoint character of the classic bildungsroman, and like the

preadolescent Huck Finn, contemptuous of "sivilization." If she cannot escape the stultifying Aunt Pollys by going down the river on a raft, she can at least take refuge in the garden seat.

Although Helen is clearly an evocation of Mansfield's own rebellious girlhood, the author takes some pains to avoid sentimentalizing the character. Helen is a hoyden and distinctly unlovable. She pouts frequently and when her father asks her if she loves Jesus, she finesses and answers with an ungenerous dodge aimed at her blameless sister. The artist in her insists that she see the life about her clinically; she cannot be bothered with the niceties of being sorry or afraid or sympathetic. She is too much occupied with the sharp observations she is making now and tucking away for future use when she becomes a full-fledged artist. For instance, in telling the story from the distance of time, she recollects some childhood scenes: her father flinging himself onto the freshly laundered bed coverlet without troubling to remove his outdoor boots; her mother's perpetual frown deepening the grooves about her mouth and the etched lines of anxiety between nose and chin; and, in a flash of apprehension, her own crass insensitivity to her parents' goals and real worries. Considering the fact that this is a very early story, it shows a good deal of honesty that compensates for its lack of subtlety.

"The Doll's House"; "The Garden Party"; "Her First Ball"

These three important stories have much in common, and should be treated as aspects of a single theme: the plight of the outsider, with its attendant pains and compensations. All three stories were written in 1921, and even a cursory reading reveals the author's maturation since "The Little Girl" of 1912. The conclusion to each of these narratives is neither definitive nor an easy solution to the complex issues raised in each. The stories are studies of growth that eventuates through the challenge of handling new experience. None ends happily or even satisfactorily,

but each concludes with an epiphany or flash of insight on the part of the young person undergoing enlightenment.

"The Doll's House"

Kezia Burnell is once again the central character in this story. This time she is matched with a true outsider, who has much in common with her and tests her fledgling humanity. The plot is simple but the point of view complex. A mood of tension is established at the outset. A doll's house has been sent to the Burnell children, conferring on them instant celebrity in their provincial community. Here, as in so many of the New Zealand stories, the very young and the outcast are united against the powerful and intolerant community of parents and other authority figures. In a few deft strokes Mansfield sketches a world of snobbery, prejudice, and exclusion as the other children fawn over the Burnells for the privilege of seeing the fabled toy. Only the village washerwoman's uncouth daughters are systematically prevented from entering the charmed circle the Burnells have inhabited since the advent of the magic cottage. This is indeed a fairy tale of sorts, but the enchanted castle is guarded by a company of bad fairies. Mansfield slyly notes that the father and mother who inhabit the miniature house are stiff and unreal. And indeed, the "dark, oily spinach green" structure is an irritant to the adults because of its offensive smell and its potential disruption of household routine through the parade of unwelcome little intruders who come to gaze in wonder and curry favor with its owners.

Parallels are drawn throughout. The schoolchildren's toadying is mirrored by the schoolteacher's sycophancy towards the entrenched families she serves and her disdain for the poor ill-bred children she is saddled with. The adults' exclusion of the lower orders is reinforced by the overt cruelty of their offspring towards the ragamuffins with whom they are forced to attend school. Kezia, the youngest of the Burnells, is matched with the

younger of the two outcast Kelvey children. Kezia is too young to have mastered the rules of exclusivity, and is therefore at the fringe of her narrow society. Disobeying her elders' injunction against fraternizing with the pariahs, Kezia spirits the two ungainly girls into the yard, shows them the treasure, and is severely castigated. But wonder of wonders, the smaller of the two, called "our Else" even by those who scorn her, smiles a rare and "radiant" smile, which illuminates her homely martyred little face, and whispers to her sister after they have regained safe ground far from the forbidden territory they had interloped, "I seen the little lamp." Without conscious collaboration, she shows herself to be a sister under the skin to Kezia, who is also transported by the little lamp, the only "real" thing in the sham house. Thus Kezia, scolded as a "wicked, disobedient little girl," and our Else, a pariah, are linked and spiritually symbolized by the pure glow of the lamp in the otherwise darkened house.

This is Mansfield's version of a "community of saints."[6] In this stratified little microcosm, only Kezia speaks kindly to the poor outcasts, and becomes an outcast herself. Only Kezia and our Else see the light, a supreme irony in that they have both been castigated as unworthy, the former for willfully breaking the rules her community lives by, and the latter for her low birth and inferior intelligence. But Mansfield clearly wishes the reader to empathize with their superior insight and spirituality as well as to sympathize with their plight as victims of an inequitable system.

"The Garden Party"

Here, as in the following story, the Burnells have become the Sheridans. They have made another move, as did the Beauchamps, Katherine's own family, to a larger house, whose sweeping lawns and gracious terraces give ample evidence of their increasing prosperity and status. But here too, as in "The Doll's House," the community is mixed, and the grand houses are uncomfortably adjacent to the hovels of washerwomen, carters,

tenant farmers, and the other assorted rural poor who are a
fixture of the countryside. In "The Garden Party" the family is
somewhat more insulated from the harsh facts of poverty because
the poor live a good distance below the large house on the hill. If
their children attend the same public school as the children of
the affluent families, the Sheridans would not know, because
unlike the Burnells, who were obliged to attend the same school
as the dreadfully common little Kelveys, they were beyond grade-
school age. The girls are nearly grown up, and the single son is
already apprenticed into his father's business.

"The Garden Party" could be called "The Doll's House,"
part 2. It is very much an enchanted kingdom, and, until the
climax of the story, its inhabitants are entirely engaged in play, or
in this case, playacting. Their artifice is so natural to their
station, their expectations, and customs, that the reader is gulled
into empathy by the very charm of their lives. It is not until
ugliness intrudes and provokes some uncharming reactions that
one is aware of just how much falseness is embedded in their
nature.

The story begins on a charmed note: "And after all the
weather was ideal." One of Mansfield's great narrative gifts is her
ability to set a tone, plunge the reader into the heart of the event,
and at the same time imply that the action has been building for a
great while. After the heady title, "The Garden Party," with its
implications of ethereal and lighthearted entertainment, Mans-
field has the wit to begin her tale with the conjunction "and." All
the anxiety and prayer preliminary to the lawn party are implicit
in that "And after all," which phrase miraculously dissipates
them. "Ideal" is the perfect description for the jumbled impres-
sions in the next pages. Blue skies, gold haze, red roses, deep
velvet lawns, and the "broad gleaming leaves" of the karaka trees
with their "clusters of yellow fruit" dominate this bourgeois
Eden. A marquee raised for the band is taken for granted; pots of
pink canna lilies are banked by the florist in careless profusion
outside the porch doors, although the house is blessed with a lily

lawn of its own; cream puffs and fancy sandwiches appear as if by magic from the town caterer and the capable hands of the resident cook. The servants are praised, the cook for her dependable calm, and "good little Hans" for his manly efforts to move the grand piano.

These are charming people. They are not whipped into a vulgar frenzy of delight by the bounty that pours forth from their cornucopia. They are used to it. Mrs. Sheridan justifies her extravagance of the purchased lilies by declaring to her only sensitive daughter: "For once in my life I thought I would have enough lilies," while still another flat is brought in. So relaxed is she in her idleness that she is charming even when she forgets the only task she is required to complete—to write the names of the sandwiches on their decorative little flags. Her two eldest daughters are equally unruffled. Jose, "the butterfly," exotic in a Japanese kimono that unfits her to do anything by way of preparation for the party, moves placidly to the piano to rehearse a "tragic" ballad, just in case she should be called upon to perform. When she finishes her rendition, a piece with the lugubrious title "This World Is Weary," her smooth face breaks into a "brilliant, dreadfully unsympathetic smile." Knowing Mansfield's propensity for irony, one may be sure that this insignificant episode will have reverberations later on. No gesture in this economical narrative is irrelevant to its outcome.

The adolescent Laura Sheridan, a grown-up Kezia, and the "artistic" one in the family, is as guilty of playacting as her philistine mother and sisters at the outset. Having no experience of life apart from the shelter of her community, she mimics those role models familiar to her. When inviting her friend Kitty to lunch, she coos in her socially adept mother's voice. When sent out to supervise the laborers who have come to put up the marquee, she takes a big bite of her bread and butter just like a real "working girl." More sensitive than the others, she falls naturally into the rhythms of those she wishes to please. Romanticizing the workmen, she is enchanted by their lingo, the way

they call each other "matey" so democratically. She finds herself wishing she could have them for friends instead of the "silly" boys at dancing school. But her high-mindedness is still untested; she could go either way.

Laura is at a particularly impressionable and formative stage of adolescence. Even in her sentimentalizing of the working class she betrays the heightened sensitivity that will soon mark her as an outsider in her own family. She finds herself apologizing for the luxury and excess of the party to a particularly pale and worn laborer; it will only be a very small band, she assures him, suddenly uneasy. Her guilt is in marked contrast to her friend's cavalier allusion to the musicians as "frogs" in their little green coats. She is moved by the sight of a workman inhaling a sprig of lavender from the vast lawn, and indulges in a reverie of a better world in which there are no "absurd" class distinctions. She has more trouble giving orders than her imperious sisters. Although she is still pretending at this stage of the story, there is a hint of her special quality at the very beginning. "You're the artistic one," her sister tells her, and Laura's reactions to her immediate environment document her shrewd observation. She "notices" things: the quality of the very air on the morning of the party; the "tiny spots of sun" playing on the household ornaments; the dark blue of the workman's eyes that contrast so with his pallor. It is Laura's gift of noticing that will change her life in just a few hours.

An accident, casually reported and overheard, alters the focus of the story and leads to a rite of initiation for the immature Laura. The crisis takes place offstage, as in Greek tragedy. An unfortunate event that just might mar the cloudless day is circulated through the servants' quarters. A young carter who lives in a hovel down the lane has been killed in a collision. The news is conveyed through the man who has brought the cream puffs from the caterer—a fitting irony carried by the perfect symbol of frivolity—and is disregarded by all the Sheridans save Laura, who insists the party be canceled in respect for the dead man.

Argumentative and seemingly intractable, she is finally seduced by her clever mother with a bribe of a large straw hat to wear to the party. "I have never seen you look such a picture," her manipulative mother assures her. Laura, catching a glimpse of her enchanting reflection, showing her pretty face haloed in the decorative hat, is deflected from her austere purpose. Her conscience slumbers for the rest of the glorious golden afternoon.

Laura's party hat is the leitmotif for the remainder of the narrative. It is the vehicle for her false values, and it becomes the vehicle for her true self, even for her salvation. Mansfield is careful to describe the hat in all its seductive detail. It is large and round and ornamented with a wreath of artificial gold daisies, finished off with a streamer of black velvet ribbon. It is notable for its extravagance, reminding us that her sister had scolded her for her "extravagance" in insisting that the party be canceled. Laura's mother is cast as the serpent in the garden, tempting the young Eve into forgetting her higher purpose. The artificial gold daisies are appropriate to the artificial values Mrs. Sheridan is holding out to her corruptible daughter. It is noteworthy that Mansfield has prepared us for the false daisies—and the false values—at the beginning, when she describes the velvet lawn denuded of its real daisy plants, which have been dug up to make room for party paraphernalia. Those humble real flowers have been discarded for the false daisies on the seductive hat.

When the long perfect day has "ripened" and drawn to a close, Laura is dispatched by her inventive mother with a basket of party goodies for the bereaved widow and orphans. Congratulating herself on her "brilliant" idea, Mrs. Sheridan is barely restrained from sending an armload of lilies as well on the grounds that "people like that are so impressed with arum lilies." Laura, laden with party scraps, again feels "different" from the others. A sense of vulgarity haunts her, but, pliant as ever, she does as she is bidden. She is desperately self-conscious in her gleaming dress and huge festive headgear.

In the monograph *The Art of Katherine Mansfield*, Mary

Rohrberger concludes that Laura has not learned much from her descent into the depths. She claims that Laura has "idealized death" as she has "romanticized" everything else in her short life. That she is still wearing the hat when she returns from her unhappy mission is, in Rohrberger's judgment, indisputable evidence that she is going back to her privileged world. If that were all, then her analysis would be unassailable. But she neglects the most significant aspect of Laura's education. The hat, which had been a symbol of vanity and shallowness at the beginning, has now become an emblem of penance. Laura must wear it as she would a hair shirt. Gazing at the dead young man dreaming his eternal dream, Laura sobs, "Forgive my hat." She then wears it home as she has done all afternoon, bringing the leitmotif to its proper thematic conclusion. In a moral sense, the hat is the vehicle that has carried Laura from heedless girlhood to maturity, from her vague "artistic" sensibility that found its only outlet in choosing the most aesthetic spot for the party tent, to the true humanity that must underlie true art. Her remorse about her festive headgear is a burst of comprehension and agonized repentance for her sin of triviality. When the old crone in the hovel leads the hatted Laura to the unmarred corpse, assuring her that "'e looks a picture," she is unconsciously imitating the callous Mrs. Sheridan, who only a few hours earlier had assured Laura that *she* looked a "picture" in her party hat.

The hat has done its work. It is a changed Laura who attempts to define the meaning of life to her brother Laurie, who shares her name and her nature. No longer smug about life's verities and certitudes, Laura has given up playacting. She asks a tentative and inchoate question: "Isn't life . . . ? Isn't life . . . ?" Her brother, a male replica of her questing, merely repeats the question, emphasizing the "isn't" and thus rendering the question an unspoken affirmation. Laura requires no further confirmation of her lesson. She has been initiated into the mystery of life through exposure to death. The little girl who a few minutes earlier had been agonizing about the inappropriateness of left-

over cream puffs to a mournful occasion has experienced an epiphany and has begun to understand the complex life outside her high protective gates.

This narrative leaves no loose ends. It turns out that life is indeed "weary," although people like Jose, the "butterfly," will go on singing about it and never comprehend its meaning. Laura has learned it, at second hand at least, from the puffy lips and swollen eyes of the young widow and the specter of the five orphaned tots. She has begun to realize that there are other "pictures" besides her young face framed in an enormous party hat. She has learned also that, in the words of the old woman in the dark shadow of the dead man's dwelling, there's nothing to be afraid of, and her morbidity and anguish may now be converted into creativity. The very inconclusiveness of her beloved brother's answer to her rhetorical question about life provides an open end for experiment and conclusion.

"Her First Ball"

The final story of the "New Zealand Cycle" is a rather clinical study of emergence from girl into female, with everything that phenomenon implies. It is a less-generous study than the others but psychologically valid. The heroine, Leila, is yet another version of Kezia/Laura, but her progress is the reverse of the other two girls'. She begins as an outsider, a country cousin to the sophisticated Sheridans, and ends as an insider, less insecure but somewhat less humane as well. Whereas her younger counterpart Laura (who is also her cousin in this story) is enriched and humanized by her exposure to poverty and misfortune in "The Garden Party," Leila is initiated into the world of pleasure and luxury that are instrumental to the flowering of her femininity but injurious to her character.

The title informs the reader that this is another rite of passage. The adolescent and impressionable Leila is invited to her first dance and is swept up in a heady jumble of sense

impressions: the murmur of soft voices, rustling silks, textures of starched collars and black broadcloth dinner jackets, scents of hothouse flowers, sheen of waxed floors, cool ices, tinkling spoons—all conspiring to dazzle the novice with their delights. Like Laura, the young girl finds herself in the midst of her pleasure faced with evidence of life's harder reality in the form of an older man who whirls her about the floor. He reminds the fledgling unpleasantly that age lies before her. The visible signs of his decrepitude, the missing buttons on his worn evening coat, his balding pate, fat paunch, and stertorous breathing brought on by the unseemly exertion of his dancing are all portents of inevitability. Left to herself after the obligatory waltz, Leila finds her confidence shaken momentarily: "Could it all be true? . . . Why didn't happiness last forever?" But youth, natural resiliency, and preference for pleasure over pain are effective antidotes to anxiety about a remote future. When the next dance begins, the music, lights, flowers, and curly head of her young dancing partner all conspire towards a blessed forgetfulness. Leila fails to recognize her first dancing partner when she passes him on the dance floor.

This story concludes, perhaps more truthfully than "The Garden Party" if somewhat less satisfying emotionally, without the full chastening shock of reality and its consequent sobriety. It deals more subtly with portents. Leila's position as outsider at the beginning is reinforced by the subliminal message extended by the other outsider, who is separated from the other butterflies through his encroaching age, shabbiness, and general unfitness to his present environment. However, when Leila finds herself more secure in her social acceptance, she separates herself from the unpleasantly prophetic outsider and retreats into the chrysalis of youth, the make-believe of the fleeting moment that is her present reality.

Mansfield's technique in this story is calculated to induce a sensory impression to carry the message. Inanimate objects are invested with vitality, even anthropomorphism. In the first para-

graphs, the cab in which Leila rides, the bolster on which her hand rests, the very wisps of tissue pulled from the new gloves, are imbued with human qualities. Even the lampposts she passed in the night were "waltzing." All these impressions are imprinted on the mind of the young girl in the sequence of their appearance as she is borne Cinderella-fashion to her first ball. As the story progresses, the images speed up. Upon entering the brightly lit ballroom, the girl is positively assaulted by color, sound, smell, and movement: "They were somehow lifted past the big golden lanterns, carried along the passage" by some energy outside their will. At the end all the sensory stimuli are fused into a kaleidoscope of impressions: "The lights, the azaleas, the dresses, the pink faces, the velvet chairs, all became one beautiful flying wheel." Leila, swept along by the lights and colors and heady exhilaration of her success, emerges from her cocoon and like Gregor Samsa's sister in Kafka's "The Metamorphosis," soars into the air transformed into a butterfly.

All writers of fiction remake life to a certain extent. The New Zealand stories are so faithful to Mansfield's childhood that they have some of the intrinsic fascination of a photograph album: the author as a chubby six-year-old; the author in her awkward adolescence; the author in her svelte and mysterious young womanhood. Reading the narrative chronologically is like looking at the snapshots in a liberally illustrated biography. Here is a picture of pretty Aunt Belle Dyer, captured with the same supercilious glance common to the fictionalized Aunt Beryl. Here are evocations of the "pa man" in the studied poses of the proper Edwardian Harold Beauchamp, alias Stanley Burnell. Photo after photo captures the elusive Kathleen, first as a model for the sturdy but skittish Kezia, then for the shy pubescent Laura, and finally, newly glamorous, hair in slick bangs, eyes dreamy yet challenging, a composite of "butterfly" Jose and rapturous Leila.[7] The reader must remind himself that Mansfield's skill has highlighted and transformed those aspects of her own life into a story about a child who develops into an artist. The New Zealand

stories are as "true" as the author perceives the underlying events and the characters who enact them, but they are clearly fiction. Mansfield has rearranged and dramatized the episodes and the roles enacted by the principals in order to emphasize her own central role as interpreter. One of her sisters remarked that if anyone was Laura in "The Garden Party," it was she, not Kathleen.[8] That Mansfield embellished the raw truth in some episodes and overlooked it entirely in others for dramatic purposes—such as the fact that in real life the father of the Kelveys in "The Doll's House" was not a jailbird as he was portrayed in the story—does not in any way negate the truth that the New Zealand stories are the most autobiographical of Mansfield's fiction.[9]

All the stories in the cycle, beginning with "Prelude" and concluding with the metamorphosed Leila in "Her First Ball," are aspects of the author, from the toddling Kezia to the debutante. Although the first narratives emphasize the members of the family almost equally, by the time the young girl approaches maturity, the author's focus is almost entirely fixed on herself. In the fiction discussed in the next chapters, the heroine is a composite character shaped by Mansfield's schooling abroad, her romances and marriages, and her chronic illness that brought her to foreign shores and acquainted her with a variety of eccentric and sometimes-tragic characters. The New Zealand era, with its childhood memories, is done with as material. As she herself noted in a fragment called "A Recollection of Childhood," "things happened so simply then, without preparation and without any shock." The natural flow of the New Zealand tales had derived from universal experience essential to the bildungsroman, and that part of her life was over. From this point on, accrued experience will shape a more "bony" fiction, reflecting the multiple exposures to the outside world, where the young woman is no longer insulated by big houses, the authority of the "pa man," the grandmother's protective shield, and the built-in privilege of the Burnell-Sheridan position in a provincial outpost of the British empire.

3

In a German Pension:
The Exile as Satirist

A decade after the publication of *In a German Pension* Katherine
Mansfield wrote to Murry that she refused to have it republished
because of her dissatisfaction with its immaturity. "It's not good
enough," she complained. "It's positively juvenile, and besides,
it's not what I mean: it's a lie." Some time later Murry did
actually succeed in securing her permission, which she granted
because she was, as usual, hard up for money, but it was not
actually reprinted during her lifetime.

An examination of Mansfield's first published book reveals
that its author was perhaps too harsh in her self-criticism. There
are aspects of the stories and sketches that make up the collection
that ring truer, to this reader at least, than some of the more
fanciful passages in more widely touted stories such as "Some-
thing Childish but Very Natural" and "Je ne parle pas français."
In spite of the fledgling author's vaunted discomfort with the
"untruthfulness" of the *Pension* contents, its stories and sketches
ring true in an absolutely personal way. Its harsh judgment of the
"Kurgäste" she encountered in the sanatorium is natural in so
young and isolated an observer and participant as Mansfield was,
and its lack of tolerance is amply compensated by its witty
appraisal of human fallibility and pretension and its compassion
for some of the misfits, who, like herself, were driven to extreme
measures of subterfuge and evasiveness in an inhospitable en-
vironment.

It should be remembered that *Pension*, although it deals with a later period than the New Zealand cycle, preceded her latter publication by ten years. Still in her apprentice period, she sometimes used a bludgeon when she intended to wield a rapier. She confused satire with irony, although it is clear that she often aimed for the subtlety of the latter and overwrote. In *Anatomy of Criticism*, Northrop Frye clarifies the mutual incompatibility of irony and satire on the following grounds:

Irony is consistent both with complete realization of content and with the suppression of attitude on the part of the author. Satire demands at least a token fantasy, a content which the reader recognizes as grotesque, and at least an implicit moral standard, the latter being essential in a militant attitude to experience.

In *Pension* Mansfield assumes the second stance. She tends to exaggerate the behavior of her fellow pensioners, creating grotesques, misanthropes, and hypocrites, to be measured against her own implicit moral and cultural standards. As in all satire, her goal is corrective. She sees much fault in the decorum, table manners, social and amatory relationships, among the residents, and feels herself shunned, scorned, and mocked, but entirely in the right in her values. If her aim is to achieve an ironic tone, she misses, because in Frye's terms, she fails to "suppress" her attitude, or project an objective tone. She is deeply engaged, and her anger and contempt are close to the surface.

The stories themselves are witty and sometimes downright funny in an "unbuttoned" unselfconscious style that vanishes in the later more refined and polished fiction. Mansfield was young enough, cocky enough, unsparing and audacious enough in that difficult time, to indulge her malice without taming her wicked wit. A hostage among gross strangers, she expressed her frank distaste for her host country and its culture, which drew from her some devastating throwaway lines delivered in the blandest Swiftian tone to disguise her total disgust for her teeth-picking swinish

tablemates. In only a few of her later great stories did she retain those crisply defined sentences and mordant one-liners that abound in the *Pension* sketches. These journeyman tales are totally free of the artificial childlike locutions of the middle period and some of the vaporish inwardness of the late work. The story-sketches in this collection, like those of the young D. H. Lawrence, are uncluttered by what Sherwood Anderson used to call the "thickly forested vegetation of the subconscious."

The *Pension* narratives in the collection are based largely upon Katherine's banishment to Bad Wörishofen in the Bavarian Alps to await the birth of her illegitimate child by Garnet Trowell. Her residence ended with a miscarriage, but she went home with a diary filled with material from her stay at the obscure pension where her mother had deposited her for the duration of her pregnancy. In the stories she identifies herself as a young married English woman who has come for a cure along with a variety of German nationals. She gives no hint of her malady, only a vague lack of appetite; she is different from the others only in her nationality and reticence. For the rest, she shares the regimen of the others, although she is clearly an outsider and treated as an alien and a curiosity. From their unabashed criticism of her modest food intake, her British reserve, and her country's social history, one deduces exactly how insensitive and coarse *they* are. For example, while they are expressing their scandalized opinion of the British primitive propensity for "pig's flesh" and bloody beef in great quantities in the story "Germans at Meat," they are themselves consuming great tureens and platters of bread soup, veal knuckle, and cherry cake, whose pits they are spitting in vast numbers. During their simultaneous tirade against British eating habits and their own gargantuan ingestion of leaden German comestibles, the author finds herself, a vegetarian and thus considered an eccentric by the others, reflecting that she, who drinks only a cup of coffee in the morning, has had forced upon her the wholesale defense of the conjured ogress Britannia to a host of swilling and sweating

accusers, while they, all unabashed, discuss freely the minute details of their ingestion, digestion, and elimination at the breakfast table.

The single device that holds the narratives together is the author's tone, which is by and large bland and amused with a sly edge. For instance, she pretends to link herself with her fatuous inmates when they are making their most outlandish requests and indulging their most hypochondriacal fantasies. In these cases her authorial voice becomes an inclusive "we." When, in the story "The Advanced Lady," she records: "We descended upon Schlingen and demanded sour milk with fresh cream and bread," the reader is expected to understand that Mansfield was along as participant-observer but in fact is exempt from the rudeness of her companions. She, Katherine, would never be that imperious; she is too insecure and lonely in that crowd. She has been continually snubbed and condescended to because she does not know her absent husband's favorite food, because she has no children, is patently no "hausfrau," and is in the English fashion shockingly flat-chested. Still, she pretends a united front with the others when she recalls: "Herr Erchardt and I had not met before that day, so, in accordance with strict pension custom, we asked each other how long we had slept during the night, had we dreamed agreeably, what time we had got up, was the coffee fresh when we had appeared at breakfast, and how had we passed the morning." There is not much harm in this affable reminiscence other than an undercurrent of mockery at the humdrum insipid routine of the pension and the pettiness of its occupants. More vitriolic, however, is the observation about the return home from the excursion: "Squeezed into the peasant cart and driven by the landlord, who showed contempt for mother earth by spitting savagely now and again, we jolted home again, and the nearer we got to Mindelau the more we loved it and each other."

The deceptive camaraderie in the three cited episodes might cause some unwary readers to be taken in if Mansfield had not laid her ground so carefully that there would be no danger of

misunderstanding her intention. The cure guests are limned in a few merciless strokes cleaning their ears at table with their dinner napkins, prying into the private lives of others, and describing the most minute details of their physical condition in mixed company. In a word, they are drawn as xenophobic, arrogant, and crude. Their dialogue, which Mansfield reproduces with unsparing fidelity, is a definitive index to their national character from the young outlander's point of view. The youthful dreamer Herr Langen in "The Advanced Lady," a perennial professional student whose mind has been shaped by an incessant stream of philosophical distillate, reveals himself in the following discourse: "Nature has no heart. She creates that she may destroy. She eats that she may spew up and she spews up that she may eat." This somewhat tolerant evocation of the muddled mind of a youth who is, in the manner of "the over-philosophical and underfed," harmless if on the verge of melancholia, is kinder than Mansfield's treatment of the other pensioners. There is, for example, "the advanced lady" of the eponymous sketch, rendered ridiculous through her own utterances. Carried away by delusions of creative grandeur, she emotes: "My brain has been a hive for years, and about three months ago the pent-up waters burst over my soul, and since then I am writing all day until late into the night, still ever finding fresh inspirations and thoughts which beat impatient wings about my heart." Mansfield lets this ridiculous character, churning in her pretensions and ecstasies, stew in the caldron of her mixed metaphors. Having delivered herself of this sonorous and self-congratulatory autoanalysis, the advanced lady then goes on to deprecate everything English, from the tailor-made English clothing designed for the flat English figure to the shallow roots of English literature, Shakespeare himself not excepted. The uncompromising condescension of the Germans towards the defenseless exile in their midst goes hand in hand with their blithe hypocrisy. Thus, the same advanced lady, gliding along the corridors murmuring "the fragrance of purity and the purity of fragrance" before delivering

herself of the profound definition of the "modern woman" (herself as paradigm) as "the incarnation of comprehending love," neglects her husband and locks her child in the kitchen.

The other sketches, episodic rather than conventionally flowing in a rising momentum of action towards a climax, are variations on the themes of "The Advanced Lady." The author's undisguised hostility towards her host nation during this most trying period in her young life appears to have afforded her some relief. It was good for her soul if not admirable in her character to paint the residents as toadies and snobs. One such story of sycophancy unfolds in the carefully executed "The Sister of the Baroness," a tale whose success rests on a case of mistaken identity. To a company of such star-struck ordinary folk, the news that a baroness is sending her small afflicted child for a cure is heady enough. But added to that honor is the intelligence that the sister of the baroness will accompany the tot until the baroness herself deigns to visit the sanatorium to claim her noble descendant. Nothing warms the cockles of the heart of the true snob as much as brushing elbows with royalty, and the propinquity of the palest tinge of blue in the blood was enough to generate an air of high tension and privilege among the convalescents:

Absorbing days followed. Had she been one whit less beautifully born we could not have endured the continual conversation about her, the songs in her praise, the detailed account of her movements. But she graciously suffered our worship and we were more than content.

The events move with unerring direction in a crescendo of knee bending, currying favor, reporting on every smallest gesture or pronouncement of the visiting patrician until the inevitable denouement. Imperious and impatient, the baroness herself arrives to claim her daughter and demands to see her maid. The pension residents, who for days had joyfully prostrated themselves before the "sister of the baroness" are stupefied when they are brutally

alerted to the truth of the young dissembler's true identity. They have been wasting their adulation on the daughter of the baroness's dressmaker, who, masquerading as their better, has succeeded in drawing from them a full measure of sycophancy.

A more human portrait, and one that reveals forbearance, if not actual compassion on Mansfield's part, is the central character of "The Baron." A tiny little man, isolated by the others as a consequence of their inordinate awe of his august rank, the baron reveals himself to the author while he is democratically sharing an umbrella with her: "I sit alone that I may eat more," he confesses, admitting that he is rarely seen because he "imbibes nourishment" in his room all day long. Ironically, after that sad yet human confession, the other cure guests, observing their most distinguished resident in open discourse with the hitherto despised little foreigner, begin to shower attention on her.

Fräulein Sonia Godowska is the heroine of "The Modern Soul," a somewhat younger version of the advanced lady, and traveling with her mother. Mansfield's skill in comedy is demonstrated in her economical yoking of mother and daughter in a joint thumbnail portrait: "The mother has an internal complaint and the daughter is an actress," implying a malady equivalent to her mother's. The characterization is a prime example of the "throwaway" line alluded to earlier in this chapter. That Mansfield puts the casual observation in the mouth of a naive and worshipful professor is a master stroke. The character of the afflicted elder lady is sketched in the single phrase, while her daughter's disorder is weighed against her mother's. The mother "quavers"; the daughter emotes. "Good evening. Wonderful weather," whispers the older woman. "It has given me quite a touch of hay fever." In contrast to her tremulous parent's natterings, the young woman is grandly mute. As a self-declared actress, she allows her actions to bespeak her passion. She "swoops" over a rosebush in a sort of *tableau vivant*. In dramatic juxtaposition to her mother's refined quakings, she presents the

picture of a splendid fiery, if somewhat long in the tooth, Fräulein of superior breeding. She wears a "tasteful garniture" of sweet peas in her yellow hair and strikes postures.

Mother and daughter are fiercely united in their denunciation of the English as "cold" and "fish-blooded," although they will grudgingly admit the superiority of English woolens, which they are not above smuggling out of the country. "England," the Frau declaims, "is merely an island swimming in a warm gulf stream of gravy." Yet the Fräulein deigns to confide her innermost secrets to the very representative of that inferior culture. Her mother, it appears, is insensitive to the finely tuned instrument of her artist-daughter's temperament and actually has the temerity to interrupt one of her daughter's performances in the salon with the indelicate observation that her daughter's skirt safety pin is showing.

The sketch ends with a hilarious fainting episode worthy of a vaudeville turn, exposing the "modern soul" as nothing more than a love-starved female at the far edge of spinsterhood. It is a tribute to Mansfield's restraint as a fledgling writer that she does not milk the situation. She permits the narrative to spin itself out as an inevitable consequence of the falseness of the "artiste's" pretensions and posturings. At the end, like a well-trained musician, she permits herself a coda, noting the way events have taken their inexorable turn, given the foolish notions of the protagonists, and ends with a low-key murmur of puzzlement. Did the shy and repressed professor, running gallantly into the woods to revive the fainting Fräulein, get up the courage to make love to her while loosening her stays? "I wonder," muses the author.

The last of the character sketches, "Frau Fischer," is just as lightly evoked, but one senses the bereft Mansfield bristling at the flaunted maternity of the smug German hausfrau making her yearly cure from the joyous burdens of her flourishing large family. The sketch is low comedy, played out between the prying aggressive Frau and the lonely, contained Englishwoman. The Frau advances, bumptious and omnivorous; the narrator holds

In a German Pension 59

her ground, resorting to outrageous lies when her interlocutor's
vulgarity passes the bounds of decency. When the German
woman insists that the young woman needs "handfuls of babies"
in order to fulfill her womanly function, her victim declares that
she considers childbearing to be "the most ignominious of all
professions." When her tormentor insists on knowing the where-
abouts of the young woman's absent husband, she invents a sea-
captain consort so realistically that she actually sees herself "sit-
ting on a rock with seaweed in [her] hair, awaiting that phantom
ship for which all women love to suppose they hunger." Finally,
unable to tolerate the Frau's onslaught of pity, advice, and crit-
icism, the narrator decides to "kill off" her romantically con-
ceived mythical husband, much as the imaginary Bunbury had
to be dispatched for plot reasons in Oscar Wilde's *The Importance
of Being Earnest*. Mansfield's beleaguered young woman decides
to "send him down somewhere off Cape Horn" and thus spare
herself another such confrontation on the following day as a
protection against unwelcome urgings to maternity.

The tone of the sketch is light, the dialogue a skillful mon-
tage of overlapping and unfinished questions and floating bits of
conversation such as would be overheard naturally in an estab-
lishment such as a pension. The attack of the inquisitive and
overbearing Frau Fischer, who declares her intention of "squeez-
ing" the young woman "dry like a sponge," is sketched against
the comings and goings of a boarding house, and the dropped bits
of verbal exchange among the other residents are reproduced
through an ear faithful to their idiosyncrasies and failings. The
proprietor of the pension, Frau Hartmann, is heard to murmur,
"We are such a happy family since my dear man died," preparing
the reader for the author's cool defense of the childless state in the
face of Frau Fischer's facile pity for her "unblessed" condition.
Further, as an "emancipated" Englishwoman, the narrator is
able to introduce a modest feminist note as she observes with
amusement the accepted subservience of German women to
their husbands. In her complacent reminiscence Frau Fischer

actually reflects with pleasure on the inferiority of her position. She recalls the occasional moments in her marriage when her husband would honor her with his presence in the kitchen and say, "Wife, I would like to be stupid for two minutes," as a justification for seeking her company. Oh, the satisfaction with which she would stroke his brow after such a declaration! Although the sketch is virtually plotless, depending for its action on the random movements and shrewdly selected conversation among the boarders, the study is singularly pointed and effective, denoting the sharp contrast between two cultures and two diametrically opposed social philosophies. Mansfield makes no claim to dispassion or even fairness to her host country during a particularly trying time in her young life. She is content to leave the reader an impression of a lonely witty girl held captive in a boorish culture founded on the "religion" of family life.

The fully rounded stories in *Pension* are distinguished from the sketches in a number of ways. Although the characters in the stories are German and the setting Bavarian, they are entirely fictional and in no way reflect Mansfield's personal experience in the pension. In the sketches, the narrator is always the thinly disguised Katherine herself; in the stories there is no single authorial voice that can be identified with hers. Each story is complete with a neatly drawn plot, characters, scenes of climax, and denouement. In spite of the clearly Teutonic identity of the characters, they are more universal in their aspirations and values than the caricatures in the sketches. (It should be noted that neither Mansfield nor Murry, in his editing, made any distinction between the stories and the sketches; it is made here because of the obvious difference between the two genres.)

The first of these stories, in chronological order, is "The Child Who Was Tired," renowned more for its indebtedness to Chekhov than for its intrinsic merit. Mansfield, who was reading Chekhov at the time, was obviously experimenting with form and imitating the Russian writer, with whom she was to identify for the remainder of her life. Her story bears a strong

resemblance to "Sleepy," a story Chekhov had written in 1888, but less than another of her stories, "Marriage à la Mode," bore to Chekhov's "The Grasshopper," although that similarity has not been noted heretofore. Although the plot of "The Child Who Was Tired" is undeniably taken from Chekhov's tale, the style owes nothing to the master, and Mansfield's narration is distinctly original. Whereas Chekhov's child is named Varka and is given a specific if limited identity, as are her mother and father as well, Mansfield's characters are unnamed generic types: The Man, identified only by his gross brutality; The Frau, large and coarse through her incessant breeding; and finally, The Child-Who-Was-Tired, whose hyphenated sobriquet renders her more a category than a creature. The characters who *are* named are curiously undefined except by their Christian names: Anton, Lena, and Hans. Their behavior, however, does not distinguish one from the others, except that one spits, another strikes out, and the third makes faces. Their sole function is to torment The Child-Who-Was-Tired and drive her to an act of unpremeditated but inevitable violence. The very abstractness of The Child's environment, composed of exploitative types in a dehumanizing household, sets the scene for her tender daydreams of surcease. The Child comes alive in a recurring fantasy of "a little white road with black trees on either side, a little road that led to nowhere." Whereas Chekhov's Varka dreams of her dead mother and father in the few moments of respite from her domestic labors, Mansfield's Child, infinitely more poetic, dreams of a distant dwindling road stretched before her. When, in an access of fatigue following the hallucinatory episode in which The Man and The Frau loom like giants and the baby appears to be alternately headless and two-headed, the "beautiful marvelous idea" of suffocating the shrieking baby occurs to her, it seems the "natural" thing to do. Unlike Chekhov's story, in which the screaming baby is described as her "foe," in Mansfield's version the baby is not so much her enemy as an obstacle to the realization of her pastoral fantasy.

The effect of Mansfield's narrative style in this story is very close to naturalism. The author shows an almost-scientific detachment in her analysis of cause and effect. She leaves The Child dreaming her blissful dream in a landscape devoid of human contamination, with a gentle smile fixed on her usually dull countenance. The consequence of her terrible act is not the author's concern. At the moment of The Child's fulfillment, the author closes the account. In the following story, however, "At Lehmann's," she is clearly identified with the protagonist, because, although the setting is similar—a household in which a young girl has been hired to do domestic work—the focus here is not so much on the exploitation of the hired girl but on her budding sexuality. Further, while The Child in the earlier story is reputed to be dull-witted, Sabina, the heroine of this story, is dimpled, pretty, and cheerful. She is intensely curious about "the facts of life," living as she does with the Frau's incessant childbirths. Thus, when a handsome young student finds her alone in the shop and prepares to seduce her, she is sexually aroused and at the point of submission. Just at that moment, she is shocked back to the frightening reality of the consequences of sexual indulgence by a rending scream as the Frau delivers her new child.

The conflict between romance and reality is addressed and solved when Sabina tears herself away from the young man and avoids, or at least temporarily averts, sexual experience. The dilemma is dealt with. The young man, handsome though he is, is a threat in that he will, if successful, propel the childlike Sabina into the adult world of pain, varicose veins, and the endless drudgery of domesticity. The conflict and uneasy resolution presents a subject that was to become one of Mansfield's "signature" subjects: the emotional pull between the two stages of female life—namely, innocence and experience. The preserved child-state appears to be Mansfield's preferred choice.

That her preoccupation with the denial of maternity arose from her abortion at the time she wrote the *Pension* stories is

undeniable, but her theme is larger than just the literal subject of childbearing in these episodes. The story "Frau Brechenmacher Attends a Wedding" again concerns itself with the sexual side of marriage and its ensuing pregnancy. But the dinginess in which the good little Frau dwells in her cluttered home is more a darkness of the spirit than the dank and depressing rooms in which she has borne five babies and is denied even a corner of privacy to dress herself for a party. The festive wedding she attends is marred by the presence of an unkempt illegitimate child who attends her mother's wedding. The stench of sweat and stale beer in the wedding hall is a pervasive reminder of her husband's uncouth sexual advances to her and her own helpless servility. After the festivities, the little frau goes home and awaits her man's amorous onslaught with her arm shielding her face "like a child who expected to be hurt."

The men in these stories, which are told from the point of view of the victimized women, are smug and insensitive. They probably had their origins in Mansfield's own father, who, though more cultivated than the fictional German males, and clearly in love with his well-bred delicate life, was a manifestly self-centered family man of an intolerant and aggressive "maleness." He was fully realized in the character of Stanley Burnell in the New Zealand stories, but in the German stories some of his traits are evoked unsympathetically, and nowhere more unsparingly than in the character of Andreas Binzer, the expectant father in "A Birthday." The similarity between Binzer's "hooking a boy" this time after an unsatisfactory number of girls to the long-awaited Leslie after the three Beauchamp girls, fictionalized as "Boy" after the three Burnell girls, is clearly a biographical narrative.

The story begins, as do most of the others in this series, with a brief compelling sentence: "Andreas Binzer woke slowly." What distinguishes this introduction from the others, however, is that this time the focus is on the male, and for a while at least, the tale will unfold from his point of view.[1] In the course of the next few

sentences the reader begins to sense the distaste the author feels for her subject. In the first two stories of Bavarian provincial life, "At Lehmann's" and "Frau Brechenmacher Attends a Wedding," the events unfold through the consciousness of two sympathetically drawn female characters. In the first two tales of what can realistically be regarded as a trilogy, a young woman is presented in the midst of her active unceasing round of obligations. In the second, a somewhat-older woman is portrayed as worn out but faithful to her unrewarded duties. The first is eager and open to life, the second is a sacrificial object. In this third part of the trilogy, the opening sentence sets the pace of the uninvolved male, sluggish in his awakening and pettish in his whining about being exiled to the "wretched spare room" during his wife's confinement. Ranged against the callous Andreas Binzer are the females of the story, uncomplaining and heroic, abetted by the family doctor, whose opinion of the prospective father is the author's own. "Flabby as butter," thinks the doctor as he catches Binzer's arm to support him as he delivers the good news of the boy's birth. The physician is actually Mansfield's surrogate in his silent reflection: "She's got twice the nerve of you and me rolled into one. . . . A woman who works as she does about the house and has three children in four years thrown in with the dusting, so to speak." The gruesome facts of her travail are merely suggested but not detailed as they were in "At Lehmann's." The emphasis here is on the craven male held up to ridicule against the victimized heroic female. The three stories are blatantly biased against the male in domestic life, limiting their character development to predictable reactions to any infringement on their male superiority of position and ingrained attitudes towards their rights and privileges.

The sketches and stories of *Pension* are models of compression and controlled impact. If they are short on philosophy, they are long on dramatic effect. Even at this early stage in her career Mansfield was adept in the use of specific symbols for human experience. Little Frau Brechenmacher's entire situation is en-

capsulated in her open skirt placket that she discovers with humiliation on her arrival at the wedding. Just as the entire past and predictable future of Hawthorne's Hester Prynne are woven into the embroidered letter she wears with arrogant contempt on her breast, the little Frau's sad and neglected life is symbolized by her ignominiously gaping skirt. One visualizes her dressing furtively in the dark passage, fearing to ask her overbearing husband to help her with the fastening she cannot reach. The dreariness of the environment in "The Child Who Was Tired" is similarly captured in a single symbolic act, when the Child takes a washcloth from the sink and "smear[s] it over the black linoleumed table." This simple mindless action is the objective correlative of a grievous darkness of the spirit that derives from despairing hopelessness. The men themselves in the stories are often little more than symbols of snares in which women are entrapped.

Frank O'Connor, the short-story writer and literary critic, wrote an essay about Mansfield called "Author in Search of a Subject" in his book *The Lonely Voice: A Study of the Short Story*.[2] While he admitted that she was "a woman of brilliance, even of genius," he faulted her for lack of "heart" in her stories. He complained of being "put off by the feeling that they were all written in exile," that he did not mean by this "merely that they were written by a New Zealander about Germany," but that they lacked "depth" and a "coherent voice." Since his essay was obviously directed towards the *German Pension* pieces, it is appropriate to address his judgment of this early collection. There is some justice in O'Connor's faulting of the work for the brittle tone of the sketches, but there is no indication that Mansfield was aiming for any deeper emotional content than they contained in their final form. They were generic character studies in the tradition of the eighteenth-century satiric essayists, who described in brief and caustic prose a number of unpleasant or amusing national types. But the stories are another matter, and here O'Connor is less than fair. They are not, as he claims, "the work of a clever, spoiled, malicious woman," and they do possess

that quality of "heart" that O'Connor insists is missing. That compassion, however, is reserved almost entirely for her victimized female characters. Whereas in the sketches the tone is equally scornful of men and women, in the stories the women come to life and extend beyond their German identity to represent universal female disadvantage, a tradition of servility that coarsens some and destroys others. The author succeeds in tracing the steps through which the natural energy and vitality of unencumbered juvenile female life is gradually sapped by the encroaching male and finally bent to the service exacted by husband from wife, master from maid, virgin from predatory male. While these stories do not pretend to be fair, they are deeply felt.

In one sense, the *Pension* stories are the most realistic Mansfield was ever to write, possibly because they reflected a very brief period in her life in a setting that carried none of the mythic overtones of her fabled New Zealand childhood. Whereas in "Prelude," "At the Bay," and the other stories set in the large colonial homes she herself grew up in she invented a life that had its basis in real experience but took on the storybook texture and mood of experience blurred by imperfect memory and nostalgia, in the *Pension* stories she dealt with finite, often painful experience that she had no desire to remember eternally, let alone romanticize. New Zealand became a reinvented spiritual source that served her again and again; Bavaria offered her sharp young perceptions rich materials for satire. When she dreamed, she dreamed of New Zealand, and the dreams had great beauty. When she was fully awake, she recorded the real pain of an exile in an unfriendly land that she yearned to leave from the first moment of her enforced residence.

4

Trouble in Paradise:
The Marriage Stories

Just as religion was the self-declared "flood subject" of the poet Emily Dickinson, the complicated subject of marriage might be regarded as Mansfield's.[1] Her stories of courtship, marriage, and the frequent failure of romantic love are not clustered in any particular collection, but appear throughout her creative life, beginning as early as 1910 with stories such as "A Blaze." Whereas in the New Zealand cycle and *In a German Pension* Mansfield is like a referee who takes a kick at the ball—her bias almost always directed against the male malefactors in victimization relationships—in the marriage stories her sympathies are directed equally or alternately towards both partners in the marriage under scrutiny. This much is clear: the marriage stories are subtle and intuitive and told from a variety of points of view. They are also frequently marked by epiphanies experienced by the characters serving as centers of sentience in each case. In these stories there is a moment of insight generated by a focal symbol such as the pear tree in "Bliss" or the dill pickle in the story of the same name. These carefully chosen symbols carry the author's meaning beyond their finite function and serve to solve a problem or clarify a conflict or illuminate a theme within the plot.

The atmosphere in the marriage stories is essentially female. While the point of view is not always sympathetic to the woman,

the aura is peculiarly feminine. One sees women gazing into their mirrors, sitting at the tea table, having their hair dressed, reclining on their sofas. We share their intimate rituals and secrets in an enclosed world in which the male is often an intrusive presence. "A Blaze" is a prime example of a "feminized" marriage story, although the female character is neither admirable nor sympathetic. In spite of the fact that "A Blaze" has been dismissed by critics such as Sylvia Berkman as insignificant and "a lurid depiction of a siren and her prey" that "need not detain us," the story is an early and instructive example of Mansfield's use of irony.[2] The plot is vestigial; the characters are drawn in bare outline. Elsa, an idle and pampered woman stretched before a blazing drawing-room fire, flirts with an old suitor but stops short of indulging him. Her defect of character goes undetected by her adoring husband who enters the sitting room after her frustrated enraged would-be lover has departed, and drops to her side with an adoring murmured tribute: "God! What a woman you are. You make me so infernally proud."

The contrast between the virtuous, high-minded but obtuse husband who adores his wife without understanding her essential corruption and the underhanded manipulative female is painted on an uncluttered canvas. The author allows her carefully chosen symbols to convey the message. Elsa's seductiveness and slothfulness are literalized in her white tea gown, her box of chocolates, and the book of fashions on her lap. Her husband's hearty wholesomeness and openness, on the other hand, are suggested by an allusion to the sleigh on which he has been exercising in the bracing wintry air while his wife has been luxuriating before the fire. The fire itself, which gives the story its title, carries a multiple number of meanings: the artificial warmth that coddles this household pet; the blaze she kindles in the lover and then refuses to extinguish; and finally, the blaze of passion and the purity of trust that is lit and rekindled endlessly in her slavish husband.

The "sleepily savage" tiger skin on the hearth is a portent of

the seduction that will take place in the "cage" of a boudoir in which the female feline crouches. The feral symbol is well chosen to prepare the reader for the "murder" of the seducer's passion by a beautiful savage creature who lulls him with her velvet paws until he is completely disarmed. Warmed by the fire, hypnotized by her husky voice, mesmerized by her loosened hair, the lover dares to approach his prey. At that moment she unsheathes her claws, and the seeming prey reveals herself as the predator. The defeated male skulks from the scene.

In this slight story, Mansfield shows very early on in her career that she is experimenting with symbolism, choosing emblems to carry theme and mood just as Baudelaire had dictated that ordinary things ought to carry "the expansion of infinite things." In this case, the depth that is typical of true symbolist literature may be lacking, but only because the issue is limited and even trivial. The foiled seduction of a selfish woman who is flirting more with bohemianism than with a real lover is not a subject of metaphysical proportion, but within its limitations, the narrative is skillfully developed. Even a detail such as Elsa's unpinned hair, disheveled after her tussle with her importunate lover, carries meaning somewhat larger than a coiffure in disarray. When Elsa's unsuspecting husband returns to the wife he adores and notes her disturbed hairdo, he accidentally drives a hairpin into his wife's head in his fumbling attempt to restore her picture-perfect composure. The young author is employing symbolist technique to convey in a single simple gesture a complex theme of conscious and unconscious disarray and hurtfulness in this marriage.

The story "A Dill Pickle" is technically exempt from the "marriage" category becaue there is no evidence that the couple in the story had ever been legally wed, but in every other way it belongs in this group. It is a carefully controlled psychological study of a relationship recalled years after it had ceased to exist, and it contains one of Mansfield's finest epiphanies. From a recollection of Katherine's girlhood friend and companion in

later life, the story might have been inspired by one of her love affairs. In an account given by Ida Baker in her memoir *Katherine Mansfield*, "she made plans with the Pole, Sobienowski, to travel to his country and then to see, perhaps Russia,"[3] but the love affair ended and the plans never materialized.

"A Dill Pickle" tells the story of a chance meeting between two lovers six years after the affair had ended. It is one of Mansfield's most "feminized" stories, told from the perspective of a highly sensitive woman, whose reconstruction of the affair is a triumph of insight and emotional recall, while for her obtuse lover it is, from her point of view, a total failure of the imagination. Smugly unaware of the pain he is causing his former lover, the man, looking as if a day had not passed since the disastrous end of their liaison, informs her that he has prospered since their parting and has even fulfilled their shared daydream of visiting Russia someday when they could afford it. All his bland reminiscences are subjected to the internal scrutiny of his companion, whose memories differ radically from his own. Such is her moral superiority to his, however, that she confesses to herself, even in her bitterness, that in some instances his recall, emphasizing the happy times, is perhaps truer than her own clinical analysis.

The epiphany in "The Dill Pickle" is a true lustration. From the ordinary condiment the man conjures up, an entire sensory world unfolds. While he blithely recounts to the woman his exotic Russian adventure, she fills in the blanks through her teeming imagination. When he describes a champagne luncheon he and his party indulged in by the Black Sea, he remarks on a dill pickle offered him by the coachman. The woman's unrealized longings are brought sharply into focus by her imaging of the spicy morsel. In a sensory unfolding similar to Proust's conjuring up his childhood through the madeleine crumbling in the lime-flower tea in *Remembrance of Things Past*, the deprived woman reconstructs the scene:

And she seemed at that moment to be sitting in the grass beside the

mysteriously Black Sea, black as velvet, and rippling against the banks in silent, velvet waves. She saw the carriage drawn up to one side of the road, and the little group on the grass, their faces and hands white in the moonlight. She saw the pale dress of the woman outspread and her folded parasol, lying on the grass like a huge pearl crochet hook. Apart from them, with his supper in a cloth on his knees, sat the coachman. "Have a dill pickle," said he, and although she was not certain what a dill pickle was, she saw the greenish glass jar with a red chili like a parrot's beak glimmering through. She sucked in her cheeks; the dill pickle was terribly sour. . . .

"Yes, I know perfectly what you mean," she said.

Her old dreams are fulfilled in his narration of the experience, but soured through denial of shared experience.

The story terminates on a note of final disillusionment on the woman's part, brought on by her companion's coarse insensitivity. The dill pickle had brought them together for a magic moment in which they breathed life into a moribund relationship. But at the very moment of revitalization engendered by a tenderly shared memory, he ruins it by reverting to his old narcissism that excludes her utterly. She had entered into his actualized experience through her capacity for imagining herself realizing with him a promise he had fulfilled without her, and he breaks the spell.

At this point, at the very end of this carefully controlled episode, which has until now been told entirely from the injured woman's standpoint, Mansfield does something very daring, which, if unsuccessful, could have wrenched the entire story out of focus. She permits the narrative to run on for a few sentences after the woman has left, thus shifting from a subjective and limited point of view to omniscience, a practice frowned upon by some modern writers. The final moments are narrated from the point of view of the astonished man, left alone after the woman has summarily risen from the tea table and walked out on him. His last words, a bid to the waitress not to charge him for the

untouched cream on the table, reveal his meanness of spirit as surely as the fantasy of his companion had communicated her ability to share his experience.

The story is a smooth unfolding of the troubled past in the context of a somewhat embittered present through the meshing of dialogue and internalized monologue. Thus, while her lover reminisces about a halcyon Christmas they had shared when they were together, she remembers how he had fussed over the cost of the caviar. Again, while he waxes sentimental abut a garden party the day he met her, she only recalls his "behaving like a maniac about the wasps." "How delighted the sniggering tea-drinkers had been. And how she had suffered." But in an access of generosity she concedes that perhaps his memory was "the truer." In this fashion, step by step, the unconscious alternating and merging with the conscious, the past with the present, Mansfield arrives at her conclusion. The process is a tour de force of construction, ending in an inevitable conclusion from the woman's point of view: that her lover was indeed unchanged and unimproved since she had last seen him. The author documents her inescapable conclusion by proving that even after she had left, he was still demonstrating a smallness of character by refusing to pay for the unused cream. The opposing symbols of cream and pickle, of course, speak for themselves. His expensive gloves and gold cigarette case offer mute testimony that he can now afford the cream, in contrast to the poverty they shared as lovers. All this is accomplished through carefully chosen symbols in a very short story.

Although "A Dill Pickle" begins with one of Mansfield's provocative short sentences ("And then, after six years, she saw him again."), the story "Bliss," one of her most justly celebrated short stories, opens with an uncharacteristically lengthy and leisurely statement:

Although Bertha Young was thirty she still had moments when she wanted to run instead of walk, to take dancing steps on and off the

pavement, to bowl a hoop, to throw something up in the air and catch it again, or to stand still and laugh at nothing—at nothing, simply.

The information in this opening sentence is scant. The reader is informed of the age and name of the heroine and is given a hint of her temperament, which suits her name in that she retains some of the high spirits of youth. A mood is established, of energy, of childlike expectancy and sheer high spirits. Again Mansfield uses her particular device of overlapping dialogue and introspection to create a mood. An extraordinary and unreasonable "bliss" has overcome this young wife and mother as she sets about preparing for a dinner party that evening. Every aspect of her life is pleasurable at the moment. She has a handsome and successful husband, a darling baby, a charming home, and exciting friends. The mood is intensified through a carefully chosen set of symbols. The fruit in the bowls shimmers with color and radiance; the baby's toes are "exquisite" and "transparent"; her own face reflected in the looking glass gives her back "a woman, radiant, with smiling trembling lips, with big dark eyes and an air of listening, waiting for something . . . divine to happen." It is only casually that the reader learns, as if by eavesdropping, that Bertha has had no sexual interest in her husband, but she will unaccountably desire him keenly on this perfect day, that she has little access to her own baby, the child having been given over, in the fashion of the time, to an overbearing and forbidding nanny, that she does not "dare" to intrude in her own child's upbringing. She sees herself in semiseriousness, as "the poor little girl in front of the rich little girl with the doll."

This is another of Mansfield's stories that is illuminated by an epiphany, but in this case, the moment is complex and deceptive. The experience of the heroine is so spiritually radiant that Mansfield's technique must be acknowledged to transcend symbolism into the metaphysical arena. Her very use of the word "divine" prepares us for transcendence. All through the scenes preparatory to the moment of epiphany Bertha has been "con-

necting." Like E. M. Forster's characters in *Howards End*, she
has been connecting all day with her home, her husband, her
baby, and most significantly, with nature, in its visible symbol of
a "tall slender pear tree in fullest, richest bloom," standing
"perfect, as though becalmed against the jade green sky" at the
far end of her garden. She has been preparing all day for some-
thing wonderful, not just the dinner party she is giving, but some
mystery to unfold and enrich her. She is waiting for a signal. But
just at that captured moment of perfect harmony with this visible
symbol of nature's perfection, on which there was "not a single
bud or faded petal," a gray cat slinks across her field of vision,
followed by a silent black tomcat. The connection is severed.

During the evening, the connections build again, leading
towards the inevitable epiphany. Bertha connects with her new
friends, all young and talented and fascinating. Symbolically
dressed in green and white like the blossoming pear tree, Bertha
"connects" for the first time to her husband and desires him
fiercely. But most of all, she connects with her newest friend, the
silvery blond and enigmatic Pearl Fulton, to whom she is power-
fully drawn. After the successful dinner, Miss Fulton gives the
"sign" Bertha has been waiting for by asking to see the garden.
The two women stand joined together in mute rapture before the
tree. It is the ultimate connection. The slender effulgent tree
"quivers in the bright air . . . like the flame of a candle," an icon
to be worshipped by its acolytes. Time stands still, and then Miss
Fulton seals the connection with a murmur, which sounds to
Bertha like "Yes. Just *that*."

An epiphany, or "sudden spiritual manifestation," is marked
by evanescence. In "Bliss" the moment is over as the light is
turned on and the guests prepare to leave. But the "connection"
or revelation proves to be false. The women are indeed bound
together by a shared aesthetic perception, which Bertha thinks
can only happen among women who are in tune with one
another. But the multiple irony implicit within the mystical
union between these two women, the light and the dark, the

married and unmarried, is that the two are sharing everything, even the same man. Bertha, who discovers her new spiritual twin in her husband's arms, faces the grotesque fulfillment of her own prophetic intuition. Of all the "connections" she has made on that day of heightened awareness, the sympathy between Miss Fulton and herself is the most profound and instinctual. The pear tree was the unifying symbol of their shared flowering, and as such gave a truthful sign to the two joined worshippers of the phallic flame. The validity of the epiphany is borne out by the last sentence of the story. Full of doubt about her future, Bertha runs to the window, prepared to see another sign of the withering of her newly found erotic flowering, but sees that "the pear tree [is] as lovely as ever and as full of flower and as still." Even though her husband has been detected in a "hideous" embrace, fulfilling the first portent of the slinking tomcat, the pear tree remains as potent a generative symbol as it was before it delivered its lie. The story's ambiguous conclusion confirms that the "connection" she has finally made with her dormant sexuality is valid although belated, and that it will persist even though she has been deprived of its fulfillment. Her final wailing question, "Oh, what is going to happen now?" remains suspended in the air, reinforcing Mansfield's intentional ambiguity.

"Marriage à la Mode" should be read as a companion piece to "Bliss." The "artistic" guests who came to dinner at Bertha and Harry Young's have come for the summer to the home of Isabel and William in this story. In the second instance, however, it is the male, William, who is the center of sentience and it is through his eyes that one sees the shallow bohemianism of his unbidden guests, and the social satire is more obvious. The charming and original young people whom Bertha was busy cultivating at her dinner party have become fixtures in the lives of the hospitable young couple here and are revealed as fraudulent and dangerous to Isabel's and William's domestic tranquility. They consist of a poet who delivers epigrams instead of poetry, a painter who is too busy assessing the proper light for his art actually to

produce a painting, and an assorted gaggle of other hangers-on and freeloaders. Isabel is enchanted, confusing the trappings of art with the real thing, but William, who toils all week in the city, and comes out on weekends to find himself a displaced person, knows the facts. But he is in love with his willful wife and is afraid of losing her. He forbears.

"Marriage à la Mode" owes much to Chekhov, though little has been made of its indebtedness in the critical literature. This story is not a direct imitation or a plot borrowing as in the case of "The Child Who Was Tired," but rather an original story based on the same theme as Chekhov's "The Grasshopper." Perhaps the reason the similarity has not been recognized is that most readers identify Chekhov's characters as typically army officers, small landowners, country doctors, and other members of the modest Russian "intelligentsia" given to philosophizing. In general this is true of the plays, but in the short stories one may often find a departure as Chekhov abandons the characters of the familiar impoverished but high-minded students and their professors for studies of vain and shallow people who yearn for glamor and fulfillment but ultimately fail. Many of these stories concern women, the most famous of which is "The Darling." This story is a psychological examination of Olenka, a woman of limited resources, who lives only through the men in her life. Olga Ivanovna, the heroine of "The Grasshopper," unlike Olenka, ignores her quiet self-sacrificing scholarly husband and surrounds herself with "artistic" leeches who flatter her and use her husband's resources. Only too late, when her husband is at death's door, does his selfish wife discover his quality. To her frantic frustration she discovers that the professional world had regarded him highly and was to reward him with a coveted prize, while she was wasting her time with sponges and throwing away her chance for true glory.

From the evidence in her letters, journal, and scrapbook, Mansfield was steeped in Chekhov's literature at the time she wrote "Marriage à la Mode," so it comes as no surprise that

Isabel is so closely modeled on the Chekhovian female so deficient in self-scrutiny. More than any other, this Mansfield story is proof of D. S. Mirsky's opinion of the Chekhov-Mansfield connection in his critical study, A *History of Russian Literature*: "If Chekhov has had a genuine heir to the secrets of his art, it is in England, where Katherine Mansfield did what no Russian had ever done—learned from Chekhov without imitating him."

"Marriage à la Mode," like Chekhov's "Grasshopper," is entirely sympathetic to the male, but unlike Chekhov, who told his tale in an objective voice, Mansfield's narration is subjective, told from the beleaguered husband's point of view. William sees all, but remains loving and unjudgmental; he is forgiving, not obtuse. Instead of attempting to regain his lost mastery of his runaway household, he indulges in wistful reminiscences about the early years of his marriage, when the young couple and their two babies lived modestly but contentedly in an unfashionable part of London. Now in their new prosperity they have moved to the country where they have been taken up by the smart set who were so charming for one evening in "Bliss," but are another matter altogether now. They have taken up permanent residence for the summer and have persuaded Isabel that her personal gifts are too valuable to be wasted on the ordinary functions of domesticity. They have quite turned her head, and in a subtle way she begins to join them in making fun of William's conventional attitudes, his open tenderness, and absence of sophistication.

This story is one of Mansfield's most economical and complex studies of the relationship between the sexes, achieved largely through the symbols of nature and artifice. The earlier idyllic marriage recalled through William's stream of thought is symbolized by nature, as he travels down to his seaside home for the weekend. William is carrying a pineapple and melon as gifts for his children, but is worried that Isabel's new friends will snatch and devour them as they are wont to do. He daydreams of Isabel in an earlier life, when she wore a jersey and had her hair in a long braid. He remembers his own childhood, and his

pleasure in shaking on himself the drops of a rosebush after a summer shower. The contrast between those halcyon days and the artificial present is symbolized by the elaborate toys his sons have now as contrasted with William's own homemade teddy bear fashioned of "an old towel with a knot in it." He conjures up the old days when the children's simple toys were strewn all over the sofas, whereas now there are slim volumes of "arty" poems whose contents are impenetrable. William admits his sentimentality but deplores the cigarette butts and snippets of arch repartee that have displaced the simple pleasures of home life. William's fatigue brought on by his labors in the hot city is symbolized by the angry welt made by his hatband as he travels home; it contrasts tellingly with the loose summer clothing worn by his permanent guests, poets and painters who write no poetry and paint no pictures. Their supreme gifts to culture consist of composing titles for the scenes they make as they dispose themselves about his lawns or analyze the exact color of their legs under water as they float idly through the day.

Like "Bliss" the story ends inconclusively. Isabel feels a moment of shame when she shares William's honest and troubled love letter with her new friends, but the "new" Isabel reasserts her independence when she is flattered by the coterie. Instead of a moment of illumination, there is a further step taken in the direction of permanent estrangement between her and her husband, whose influence dwindles as he retreats into the city once more. There is a gradual congealing of personality as Isabel laughs away her momentary guilt with her new tinkling laughter. Even her old name "Isabel" has been subsumed by her new one. She is now called Titania by her hangers-on, and she is, indeed, no longer William's wife, but queen of the fairies.

"Poison" and "The Man without a Temperament" should be discussed together, because, in addition to being told through the male point of view, as is the preceding story, they portray the male in exile. Each is a sympathetic study, but the latter has an autobiographical slant, as it is based on the periods when Kather-

ine Mansfield's husband accompanied her to Mediterranean re-
sorts for long periods of time where she sought recovery to health
and he tried to cultivate patience in his enforced idleness. Much
of the interest in this story lies in the minor characters, who are
portrayed in all their neurosis and eccentricity, each foible point-
ing up an endured deprivation in the long-suffering patient man.
The resort with its separate tables inhabited by a variety of guests
provides a dramatic setting for the purpose of comparing Robert
Salesby with the others. The honeymoon couple, in a frenzy of
erotic activity, serve to dramatize the absence of sexuality in the
marriage of the tubercular woman and her self-contained hus-
band. The "Topknots," two elderly ladies, are old maids and thus
exempt from a personal life. The American woman and her dog
are outsiders and ridiculous ones at that, emphasizing the isola-
tion of exile and symbolizing Salesby's position as lapdog to his
wife. The countess, accompanying a brutal and imperious colo-
nel, typifies the demanding nature of invalids.

Two episodes illustrate the discomfiture of the seemingly
neutral self-controlled husband. The sluttish maid who makes up
the room confronts him with "impudent" eyes when he goes to
retrieve his invalid wife's shawl. "*Vous desirez, monsieur?*" she
challenges him in a calculated double entendre. A second epi-
sode points to the grotesqueness of his situation. Three small girls
are bathing naked in a tub of water, and scream when they see
him. "The Englishman!" they shriek and run away. He pales.
His wife speculates about their flight. "Surely they were much
too young to . . . ," but does not finish her conjecture when she
sees his distress.

This is a very tender story, in which habit, love, and patience
commingle in the man's behavior, although the reader is not
granted insight into his true feelings until the end. A dip into the
past produces an epiphany, as the slumbering invalid murmurs,
"Boogles," a pet name she has not called him for years. As their
carefree youth is recalled through the foolish endearment, a wave
of emotion surfaces in the man's habitually impassive face, cut-

ting through his guard. The man without a temperament, who has been an object of ridicule to the others, who call him an ox behind his back, is revealed as a man of deep commitment as well as heroic forbearance.

Whereas this story may be interpreted as self-serving because it lies so close to the author's own bone, "Poison" is much more objective, even though it is told once again from the point of view of the doting male. The couple in this story is in exile also, but it is self-imposed because they are not married but have run off together to live in the south of France. In this story the male narrator is unnamed, but his companion is called Beatrice, perhaps as an ironic allusion to her "blessedness," because, unlike Dante's beloved, she proves to be a false source of inspiration. While her lover reflects upon her beauty and begs her to assure him of her loyalty, she restlessly awaits the postman to bring her letters from the outside.

This is a psychological "murder" story. The metaphor of poison is utilized with subtle impact. The woman explains to her besotted lover that couples invariably poison each other in small cumulative doses, adding that her two husbands poisoned her, the first in massive doses, the second in small imperceptible potions, until they killed the marriage, each in his own way. When, at her companion's insistence, she reassures him, somewhat scornfully, that she knows that he "wouldn't hurt a fly," he begins to know that she has little regard for him, simply because she has a perverse relish for cruelty. His afternoon aperitif begins to taste bitter, as if it were poisoned.

An epiphany is ordinarily a manifestation that releases a larger realization. Mansfield uses the device in this case to generate an obverse illumination. Just as the narrator tries to explain his devotion to Beatrice by insisting that she, "instead of poisoning people, fills them . . . with new life, with radiance," she dreamily asks him to go again for the mail. It is at this moment that he tastes the poison. A final subtle irony is implicit in the nature of the drink: it is conventionally an appetite stimulant

taken before dinner, and may, for the purpose of the story, be taken figuratively or literally, for this poor dupe will never have his appetite for this elusive woman fulfilled.

A more poignant story about unequality in love, with its familiar signature theme of the pursuant lover and the elusive beloved, is taken from her own family, and is entitled "The Stranger." It is a variant of the dynamics between Linda and Stanley Burnell, she so desirable and detached, he so panting and importunate. Because all its frustration is compressed into one painful episode, it is more affecting than many of the other manipulated tales of marital disharmony. The story concerns the homecoming of a wife who has been absent for many months on a visit to her daughter, and records with great fidelity, from the husband's point of view, his elaborate preparations for her return and his state of high excitement and anticipation. He is like a schoolboy in his emotions. In contrast, his beloved Janey's "half-smile," her "cool little voice" when they reunite, establish clearly that, fragile as she is, she holds the whip hand in the relationship. Even while her chafing husband dances attendance on her while she prepares to debark, she, leisurely and composed, vanishes airily for long periods of time. The impression her huband has of her enormous popularity on board ship engenders in his powerful proprietary instincts tremendous pride and uneasiness. The mere sight of her trunks labeled "Mrs. John Hammond" elicits from him a sigh of reassurance.

The plot turns on an obscure incident that Hammond discovers only accidentally. Hearing from members of the ship's company that his wife has been a great favorite, he is not surprised. But the additional information that she has held a young man in her arms just on the previous night while he was dying of a sudden heart attack was "a blow . . . so sudden that Hammond thought he would faint." In a master stroke of irony Mansfield paints a portrait of a virtuous woman whose only fault in an exquisitely balanced nature is that she loves all mankind equally, reserving the bulk of her care and compassion for those

who need her most, such as her children and people in frail
health, confident that her robust husband can manage on his
own.

There is a telling scene in this story that encapsulates the
essential conflict between the two characters. In the privacy of
their hotel room Hammond, deeply aroused, asks his wife to kiss
him: "A slow deep flush flowed into his forehead. 'Kiss me, Janey!
You kiss me!'" His wife complies with a light kiss that "wasn't at
all what he thirsted for. He felt suddenly, horribly tired." The
contrast between his inability to capture and possess her and his
image of the young man dying in her arms, which opened to him
of her own volition, has "poisoned" the moment, has darkened
his soul. He would never possess her.

The theme is similar to the central theme in Robert Frost's
tour de force sonnet, "The Silken Tent," in which a young
woman is praised because she "seems to owe naught to any single
cord / But strictly held by none, is loosely bound / By countless
silken ties of love and thought." The difference, of course, is that
Frost admires the subject of his accolade for the very freedom
and flexibility so threatening to the dominant male in "The
Stranger."

The final two stories in the marriage series ought to be taken
together, because intentionally or not, they are companion pieces
of a sort, and are presented one after the other in *The Short
Stories*. In "Honeymoon" the young couple could very well turn
into the still youthful but more domesticated couple in "A Cup of
Tea." But at the present moment they are captured in the first
flush of their married state on a Mediterranean wedding trip. At a
café, where they take afternoon tea, they hear a strange sad song
sung by an itinerant old entertainer. The gleanings of the pos-
sibility of sadness or ugliness in a world illuminated by the first
flush of love is enough to send the two skittering back to their
villa and the safety of their ignorance of the real world.

In the second story, the young lovers have matured into
Rosemary and Philip Fell, married for two years, prosperous and

the parents of a child. The atmosphere of their unstinting priv-
ilege is captured in a few masterful scenes. Rosemary may buy all
the flowers in the florist's shop on an impulse and may flee the
shadows of a dark afternoon by purchasing an inordinately ex-
pensive trinket in an antiques shop where she is waited on by a
fawning shopkeeper. Her limousine whisks her away at dusk to
the cheery fire laid in her elegant boudoir by a staff of well-
trained servants. A handsome and indulgent husband makes all
her luxury possible.

Rosemary's protected environment is threatened in a single
moment, brought about ironically by a facile generous gesture,
an act she can well afford and causes her neither discomfort nor
sacrifice. Approached by a poor street girl for a coin to allay her
starvation, Rosemary impulsively takes the young waif home
with her for a nourishing afternoon tea. To Rosemary it is a lark
as well as an easily purchased salvation, or a virtuous recompense
for her own good fortune. When her husband comes home and
takes a look at the girl, he immediately notices something that
Rosemary in her self-congratulatory orgy of munificence had
entirely overlooked. Announcing to his astonished wife that he is
"bowled over" by the "astonishingly pretty" object of his wife's
charity, he casts the first shadow on their heretofore cloudless
Eden. Rosemary immediately dispatches the girl with aplomb
and a bribe of ten pounds. Then, in a panic she makes up her
face, perches on her husband's knee, extracts from him a promise
of the expensive trinket she had priced during the day, and then,
in a blatantly seductive act, presses his head to her breast and
whispers, "Am I pretty?"

The stories discussed in this chapter might be shuffled and
rearranged in a number of thematic and chronological ways. "A
Cup of Tea" might be regarded as the middle point in the
marriage relationship, a short while after the wedding trip of
young Fanny and George in "Honeymoon" and a few years
before the troubled and hollow marriage of Bertha and Harry
Young in "Bliss." In order to complete the inevitable downward

trajectory of the married state viewed in disillusion, one ought to conclude with one of Mansfield's longest unfinished tales, entitled "A Married Man's Story." This story is worth examining because it is one of the few that fails on account of its inauthenticity of "voice." It purports to be told from the point of view of the male in the marriage, as the title indicates, but it does not ring true. The story is a leisurely reminiscence of a domestic relationship that has suffered estrangement and disillusionment, but although it claims to be the husband's account, sentences such as "We were marvelously, radiantly happy" carry a decidedly female inflection. Perhaps because in these "feminized" stories one identifies such locutions as authentically female in tone, one doesn't "buy" these excessively emotional defenses as authentically male. This story fails in persuasiveness because beneath the fatuous male explanation for a failed marriage, there is a palpable undercurrent of female superiority of insight and mute suffering under the male yoke.

The following passage is an example. When the wife asks the husband to reveal his thoughts, and he evades her by denying that he has been thinking at all, he reflects: "Will she never grow accustomed to these simple—one might say everyday little lies? Will she never learn not to expose herself—or to build up defenses?" Or, when he sees his wife's back bent as she stands alone in the kitchen, her head bent over some household chore: "And nobody is going to come up behind her, or take her in his arms, to kiss her soft hair, to lead her to the fire and to rub her hands warm again . . . and she knows it." This meditation is passed off to the reader as the husband's, but no man caught in a failed marriage is that sympathetic towards the wife he no longer cares for. Because Mansfield's narrative voice is so innately feminine, she does not often succeed in conveying an authentically male narrator. She can try to imagine a man's point of view, but she is as persuasive as Viola getting herself up as Cesario in *Twelfth Night*. She might put on knee breeches, but she talks like a girl. "A Married Man's Story" is one of those instances in which

Mansfield takes that "illegal" kick at the ball, and her thesis is less credible for her infraction.

It is also true that the final verdict cannot be brought in on this and others of Mansfield's unfinished stories. Perhaps, if she had returned to them, a little judicious editing on her part might have purged them of some of the irritatingly "precious" descriptions, the overuse of sentimental words and images such as buds, larks, and "merrily twinkling stars."

Mansfield's attitude towards the interaction between the sexes in the courtship and marriage stories should not be taken as feminist in any modern sense. They are not written in the mode of stories by early feminists such as Charlotte Perkins Gilman, Kate Chopin, or Margaret Fuller. She does not agitate, as Fuller did, for more egalitarian education for women, or envisage a utopia of exclusive female society as Gilman did in her novel *Herland*. She was not troubled, as Chopin was in *The Awakening*, by the plight of the woman who has not secured her own independence or framed her own identity. Mansfield, who came along later than these pioneering writers, was rather more old-fashioned in her vision of feminine fulfillment. Her women are, by and large, modeled after Rousseau's Sophie, the young girl who would be educated to be Emile's ideal wife. Trained to serve her husband, who has himself been trained to achieve independence, Sophie is urged to excel in the womanly arts of adornment and domestic skills—in short, in pleasing her husband or lover. When Mansfield's women fail in those mandated skills, they are unhappy and insecure. Like Bertha Young and Rosemary Fell, they live through their husbands' power and approval. Although they are by and large intuitive, they are not resourceful. Their epiphanies are moments of illumination about their predicaments and rarely take them beyond the instant of recognition towards solution. The reader is not often treated to the spectacle of a married couple who are harmonious because they are equal in their roles. Rather, these married pairs aspire to that balance of power and rewarded subordination that John Ruskin

envisioned in *Sesame and Lilies,* a Victorian actualization of separate complementary spheres.[4]

Mansfield's rather old-fashioned view of marriage, discernible behind the modern touches of cigarette smoking and bobbed hair, is not surprising in light of her own post-Victorian childhood and the model of her proper parents' staid morality. In the final analysis, in the love stories happiness is defined in terms of the husbands' fidelity and their wives' efforts to please them in return for a padded nest. The occasional woman who has an itch towards infidelity, such as the woman in "Poison," earns the author's contempt.

Thus it would be a mistake to place Mansfield in the company of twentieth-century feminist writers on the evidence of her marriage stories, even though she frequently presents the woman as the victimized partner in the union. Rather, she should be seen as a transitional writer in the context of her changing time, perhaps a residual romantic with a touch of submerged lesbianism that sometimes surfaces, as in "Bliss," with Bertha actually falling a little in love with Pearl Fulton. For the rest, the term "modern," as used frequently by characters in stories such as "Marriage à la Mode," rarely goes beyond bohemianism to the contemporary meaning of feminism. Mansfield never addresses herself to hard issues in feminist thought such as education, equality of opportunity, economic independence, or true equality between the marital partners.

5

Neurotics, Eccentrics, and Victims: Stories of Character

Like her acknowledged master Anton Chekhov, Mansfield became an adept at the story that anatomizes character and temperament through a significant emblem, a loaded statement, a minor idiosyncrasy. The animation of an ordinary lifeless object such as the "sea of coloured blouses" and "quivering hair-bows" of the pupils in "The Singing Lesson" establishes the same tension that the "flickering light" in the little servant's room does in Chekhov's "Sleepy." Mansfield began writing character studies at a very early age, and ultimately developed the genre to a high art. Even so youthful a sketch as "A Truthful Adventure," in which the author scarcely bothers to disguise herself but calls the protagonist Katherine, shows evidence of that attention to the easily overlooked nuance of behavior or gesture that reveals character and conflict in a flash.

Away from home for the first time on a trip to Bruges in Belgium, the young Katherine, lonely and feeling inadequate in the face of centuries of European history, happens upon an old girlfriend from New Zealand. The meeting, which should have proved a source of comfort to her, turns out to be fraught with what Chekhov would have called "poshlost," conversation that was at once vulgar, trivial, and, to the young girl, ludicrous.

Everything "touristy" that the impressionable fledgling artist was seeking to avoid in her immersion in the ancient city is thrust on her by her crass compatriot. The banality of her acquaintance's gush stands in sharp contrast with her unuttered soliloquy. "You know," her former schoolmate babbles, "Bruges is simply packed with treasures and churches and pictures. There's an outdoor concert tonight in the Grand Place and a competition of bell ringers tomorrow for the whole week." Her unimaginative sightseeing program is superimposed on the narrator's internal resolution: "At evensong I shall lie in the long grass of the Beguinage meadow and look up at the elm trees—their leaves touched with cold light and quivering in the blue air—listening the while to the voices of nuns at prayer in the little chapel." The portrait of the artist as a young woman is of course the design of the sketchy story. The narrator, with her senses alert and simultaneously recording impressions that have nothing to do with external events or occasions, is contrasted in a single paragraph with her less inspired friend. The sharp distinction between the poetic temperament and the tourist mentality is instantly effected through a scrap of conversation. The artist has a mystical union with nature that the ordinary person lacks.

Through the alternation of dialogue and monologue, Mansfield was to hone the craft of character portraiture to a fine art. Eventually she would succeed in a complex interweaving of imagery, detailed description, and lengthy passages of internalized streams of thought to achieve fully realized characters. One of her most successful achievements, albeit of a singularly unsympathetic type, was the central figure in the story "Mr. Reginald Peacock's Day." The very name the author assigns her hero tells the story. Reginald Peacock is one of Mansfield's favorite types, a caricature notable for vanity and selfishness. According to Alpers's biography of Mansfield, he is supposedly modeled on her first husband, George Bowden, described as a musician who has enjoyed the patronage of well-heeled ladies through the "flowery path of a choral scholarship" and a reputation as a

"gentleman-artist" with a "bedside manner." The plot of the
story is nearly nonexistent. It unfolds as a species of docudrama,
with the author following Peacock through his day, recording its
events with meticulous fidelity. His character is neatly captured
without the benefit of authorial comment, merely by showing
him in his private and public roles. In his domestic life he is
revealed as a whining narcissistic infant, abusing his long-suffer-
ing and gentle wife. Throughout his professional day, he is
charming, flirtatious, and fawning. This two-sided and fully
fleshed portrait is accomplished through a single effective device:
the internal stream of thought. The entire day's schedule is
filtered to the reader through Peacock's mind, from his prepara-
tion for his appointments, vocalizing, preening before the mir-
ror, and practicing his hand-kissing techniques, to the letdown he
feels when he must return to his modest home to his neglected
patient wife.

The story turns on an irony that encapsulates the confusion
of values and insincerity in the character of the voice teacher. All
through the day he has addressed his highborn female pupils with
a well-worn phrase of flattery. As he ushers them out he responds
to their invitations to their musicales, their small select dinners,
and their soirees with the polished formula, "Dear Lady, I shall
be only too charmed." After the whirl of his glamorous day,
culminating in a tête-à-tête with a nymph named Aenone Fell
and a splendid dinner with Lord Timbuck who addresses him as
an equal, he returns to his humble apartment and finds his wife
asleep, "squeezed over to her side of the bed," as self-abnegating
in repose as in her waking hours. Rousing her with his noisy
bedtime rituals, he determines to make an effort to treat his wife
for once as an equal as he has been regarded all day. But, the
author concludes, "for some fiendish reason, the only words he
could get out were, 'Dear Lady, I should be so charmed—so
charmed!'"

The petty incident is vile yet painful, both to the participants
and to the reader. The wife's reaction is not recorded, but the

reader feels indignation for her. The author's unwavering focus remains on Peacock, a sad excuse for a man but a predictably human failure unable to utter anything but a trite sentiment to the person closest to him in the world. Contemptible as he is, he is as much a victim of his fantasies as his wife is of his selfishness. All day long he has lived in a magical world of his betters, dreaming, while he was singing, of the party to be held that evening, of "their feathers and their flowers and their fans, offered to him, laid before him, like a huge bouquet." In the story's alternation of scenes of reality and illusion, the character's real inadequacy is dramatically exposed. The wife's pain is implicit but not articulated, because Mansfield's thesis rests on the deficiency in the husband's character that causes him to worship false idols and scorn his familiar and protective household gods.

Miss Ada Moss in the story "Pictures" is, in direct contrast to Mr. Reginald Peacock, firmly rooted in the here and now. Much more naturalistic in style, and entirely free of decorative flourishes, the story is a detailed and unsentimental portrait of an old fat chorus girl down on her luck and pressed to the wall. The ills of aging flesh, varicose veins, and chilblains brought on by her unheated rented room are meticulously recorded, as are her unsuccessful rounds of the hiring halls for a bit part in a musical comedy. The solid fleshly ambiance of this sordid story is kept sharply in focus through carefully chosen symbols: the blue serge and artificial violets in which Ada Moss sails out in search of a job; the "great knots of greeny-blue veins" on her fat white legs that tell the story of long hours on her feet waiting for a call; and the "sausage finger" of the stout gentleman who "saves" her by paying her for the sexual work in which she is still serviceable.

Although this character study is unambiguous, any attempt to draw a message or moral from it is gratuitous. It is simply a coolly rendered slice of life, near scientific in its microscopic scrutiny. Miss Ada Moss is neither good nor bad. She is redeemed from bathos by Mansfield's naturalistic technique, and exempt from unwarranted sympathy by her perfectly credible

coarseness that has been shaped by a predatory environment. Throughout the sketch, like a ship in full sail, she is always in motion, buffeted by the wayward winds while she attempts to navigate the dangerous shoals with just enough courage and know-how to keep afloat. At the end, determined to survive, she follows the "gentleman" to his rooms. "Wearing a very small hat that floated on top of his head like a little yacht," her gallant steward holds out a lifesaver to the overripe siren, and Miss Moss "sail[s] after the little yacht out of the café."

"Miss Brill" is another full portrait of a "marginal" woman, told from the subjective point of view of an aging insignificant character. However, whereas Miss Ada Moss is an embattled survivor, the genteel Miss Brill is an observer of life, one who sits on the sidelines and watches the game in all its striving, contending, cruelty, and passion. She is as frozen in time as in a sepia photograph, wearing her ratty fox fur as if she were at the theater instead of seated on her usual bench in the park on Sunday, observing the scenes played out one after another. She even fancies that she, the receptive audience, might be missed by the players if she were to fail to show up for one of the performances. Her illusion is cruelly shattered when she accidentally overhears two young lovers making fun of her as she avidly eavesdrops on their lovemaking.

In the unconscious irony of Miss Brill's final behavior, the onlooker aspect of her life is reinforced. As she puts away her Sunday fur, she imagines she hears something crying in the box. So inauthentic is her life, made up of secondhand experience as well as secondhand furs, that she is incapable of recognizing the origin of her tears, which of course, is her grief and humiliation. It is more natural to her to imagine that the weeping comes from the glass eyes of the fox's head on the boa.

The four stories discussed so far share a common narrative structure. The author follows her characters through the events of their day, alternating actual events with the characters' private interpretation of their experiences. This single technique that

yields up a multifaceted character derives from the author's narrative pace, which is rapid and economical, and in full control of the scenes that are juxtaposed for the purpose of contrast between the reality of their daily lives and their private yearnings and illusions. In "Mr. Reginald Peacock's Day," for example, Reginald is literally followed by the author, who dogs his footsteps through the various rooms of his modest home, then on to the salons of his wealthy clients, and finally, to complete the cycle of his day, back to the bedroom where he was first met that morning. He has been revealed in these connecting yet contrasting scenes as self-indulgent, peevish, demanding, fawning, preening, and finally, inadequate. In scene after scene the real mediocre man has been counterposed alongside the performer. In each case he responds to his environment with the spontaneity of a shallow nature imbued with large visions of self-aggrandizement.

In the study of Miss Brill, the narrator follows her from the privacy of her humble rooms to the exposure of the public park, where she partakes of other people's joys and sorrows in voyeuristic pleasure, and then accompanies her to the bakeshop where she seeks to sweeten her weekly Sunday outing with a slice of cake. Again, as in the previous tale, the cycle is complete when the author sees her safely back in her room at the end of her day. But although the setting is familiar, she has been irrevocably changed by the events of the day that evolved so naturally in the connecting scenes, but contain one small insignificant moment that ruined not only this day, but would poison her Sundays henceforward.

The dramatized scenes in Miss Ada Moss's day, like the others, are logically connected, and like the others, contrast with each other for the purpose of ironic impact. The three scenes are her shoddy room in a boarding house where she is not welcome because she cannot pay her rent; the booking agent's where she is not welcome because she is too old to be employed as a show girl; and finally, the café, where she is anonymous but welcome

because some man will come along and pay for her drink and dinner. The title of the story, "Pictures," is evocative of the visions of nourishing meals floating over her head in her hungry morning state, to the final picture, in which the prospect of a satisfying dinner is realized through the exchange of sexual payment.

The technique of juxtaposition of scenes dramatizing the real and wishful lives of troubled people is developed to a much more ambitious extent in Mansfield's most celebrated character stories, "The Life of Ma Parker" and "The Daughters of the Late Colonel." In the first, Mansfield once again pays tribute to Chekhov, in creating a female servant based on a male cabman in Chekhov's "Misery," who tries without success to tell his fares his tragic story; he has just lost his son and continues to recount his sorrow to a succession of strangers who have hired his cab in order to relieve his feelings and extract some sympathy from his fellows. He ends up telling his story to his little mare, who munches her oats patiently through the sad narration.

"The Life of Ma Parker" is in no sense a copy of Chekhov's, as is "The Child Who Was Tired," but it does use the bare bones of the Russian writer's plot. For the rest, the story is entirely original, although it strives for the profound compassion that marks the best of Chekhov's stories about ordinary people who are victimized by their lot. Mansfield's Ma Parker is such a victim, poor and uneducated, consigned to live at the very edge of the economic and social structure by an accident of birth. Hers is an uncelebrated life. If Chekhov's servant is a male sleigh driver who transports ill-mannered gentlemen for a slave wage, Mansfield's is one of the army of "ladies who do" who let themselves into the lodgings of cultivated gentlemen for a half-day's pay to clean up a week's worth of dirty dishes and other residues of the impecunious intellectuals' genteel shabby lives.

Ma Parker is one of those characters whose marginal lives are traced through connecting scenes of present circumstance and recollected scenes of the past. In this story Mansfield has hit her

stride and controls her subject through the use of meticulous naturalistic detail. The full tragedy of her life unfolds as step by step the author evokes the old woman's sad plight. She releases her information bit by bit, until the reader has a fully rounded character, contending with the present while she retraces her inexorable past, all the while drudging away with stoicism. The first scene locates Ma Parker at the flat of the literary gentleman, responding to his mechanical query about her ailing grandson. To her dispirited "We buried him yesterday, sir," he says with condescension, "I hope the funeral went off all right." It is not so much her employer's callousness as his conviction that the lower classes "set such store" by conventional rites such as funerals that encourages her to hug her secrets close to her bosom. Still, her gentleman's suggestion about the "pleasure" intrinsic to the funeral actually does set off pleasurable memories in the charwoman's mind. As she sets about her menial chores she is transported to another place in her past, sitting in a deep chair with her grandson snuggled in her arms. As she daydreams, conjuring up the delicious feeling of the small breathing presence in her sheltering arms, the boiling kettle awakens her to the sordid dregs of her reality, the indescribably filthy kitchen that she must put in order for the "gentleman." The monotony of her task triggers another recollection, and the scene shifts again to the past. In paragraph after paragraph, her debased present is connected to and contrasted with the past, which admittedly was hard but compensated by the love of her grandson. Fleeting moments of the child's freely given affection are recalled with alternating scenes of her servitude. She remembers her grandson's piping "gran" when he addressed her, in marked contrast to her employer's allusion to her as a "hag," and the child's wholehearted trust in her generosity as distinct from the gentleman's accusing her of filching a teaspoon of cocoa. The irony of the "gentleman's" boorish behavior to a poor old servant and her own gallant self-control in the face of callousness is apparent in Mansfield's carefully uninflected narration.

"The Life of Ma Parker" is not a conventional story. It has no real plot. The recollected episodes of an ordinary person's life are psychological tools for understanding the character of a simple woman whose grief is poignant although her story lacks tragic dimension. The double pathos of this elemental tale lies in her loss and her total isolation. She accepts her lot, but lacks the equipment to work through her unhappy situation. She simply has nowhere to go after the child dies. Although her material circumstances have not altered, the real core of her life is gone. Leaving her gentleman's flat, where she is an unwelcome temporary necessity in his selfish life, she dreads going home where she will have to face her daughter, the dead child's mother, and relive her sorrow. She has nothing to soften the impact of her loss, and no heroic resources to enable her to rise above it. She has had a hard life, as she once explained to her gentleman, and its single consolation is gone.

Death, or rather, its consequences, is likewise the subject of "The Daughters of the Late Colonel," and here too there is nothing heroic or tragic about the deceased or those he left behind. However, whereas "The Life of Ma Parker" is more a sociological case study than a fully developed story, "Daughters" is full of action. The tone is set in the first sentence: "The week after was one of the busiest weeks in their lives." The busyness is both physical and emotional, attesting to the deep agitation and displacement experienced by the two spinster daughters of a severe autocratic father, the late colonel of the title. A deficient yet dictatorial parent in his lifetime, he has left his daughters a legacy of dread and impotence in their bereavement. Although they are well into their middle years, their behavior is decidedly childlike, if not downright childish at moments. Yet they are clearly distinguishable from each other in temperament and response. Josephine, the elder, is irascible and authoritative; Constantia, her younger sister, is soft and wavering.

"Daughters" is a species of black comedy. All the characters are eccentrics, from the two spinsters with their respective pallid

and florid complexions and their uneventful lives mired in petty detail, to the tyrannical old man who has expired after opening just one eye in his purple face. Even the hired nurse who tends the old ramrod in his last illness is a highfalutin caricature with an exasperating laugh "like a spoon tinkling against a medicine glass." What saves Josephine with her "small bead-like eyes" and Constantia with her long pale face from being equally grotesque is the genuine pathos of their situation. They bear the psychological wounds of their father's harshness, which has left them so fearful that they have not the courage even to demand the service due them from the contemptuous kitchen maid, who alludes to them as "the old tabbies."

"Daughters" is a fully developed story in eight parts, one of Mansfield's longest. Each sequential scene moves the story of the women's adjustment forward by retracing their past lives under their father's iron fist, while all the time they are preparing for the funeral and their ensuing orphaned existence. Thus the events move forward and backward in time in each short chapter, revealing additional aspects of the hedged-in lives of the sisters. In parts 8 and 9 their deprivation and gullibility are demonstrated through a flashback to a recent episode. The two are lamenting the failure of their nephew Cyril, the old man's only grandson, to attend his grandfather's funeral. The old maids' emotional deprivation is manifest in their sentimental indulgence of their handsome nephew, who is a thoroughgoing rotter. While his aunts are extremely generous to him, planning to give him the old man's gold watch, the young wastrel avoids paying his respects, even though they stuff him with "rich dark cake that stood for Josephine's winter gloves or the soling and heeling of Constantia's only respectable shoes."

"Daughters" is one of the stories that best illustrates Mansfield's comic gifts. The two sisters are a Laurel and Hardy duo—the one plump and ineffectual, the other desiccated and prim—both ludicrous in their regressed infantilism vis-à-vis their domineering parent. Even now that he is safely dead, they are sure

that their "father would never forgive them for daring to bury him," let alone having the temerity to go through his personal things for bequest. The terrifying old man, recollected by his cowed daughters, is literalized through the same frivolous emblem that serves for his playboy grandson. The costly meringues that his doting aunts have bought to lure the young man to tea are recalled later in the same scene when the colonel, just before his demise, cups his hand "like a purple meringue shell over one ear," the better to hear his daughters' silly natterings and roar his disgust like the sounding sea.

Mansfield's comic art is achieved within the emotional frame of the story and finally intensifies the pathos of the sisters' lives. The humor of a given situation is realized through symbols seen in more than one perspective. Thus, the meringue representing the extravagance of the two sisters also signifies the nephew's airy carelessness of their caring. He disremembers whether his "poor dear father" had been fond of meringues also, as he must have been, given his heredity. And finally, that some meringue, which predominates in parts 8 and 9, is given its final hilarious explication in the ensuing scene, when the irascible old man, just before his expiring, cups his meringue shell hand over his deaf meringue ear, and demands to know what his two cowed daughters are yammering about. They have been endeavoring to impart to him the information—vital to them but gibberish to him—that his late son had been fond of meringues. "What an esstraordinary [sic] thing," he broods, after the dawning light of comprehension, "to come all this way here to tell me!" The meringue itself, a fluffy insubstantial cake literally composed of beaten air, is a pertinent emblem of the content of all their insignificant lives.

The resolution of the story restores the balance necessary to its credibility. The pace of the narration itself slows down, as do the lives of the sisters after the hectic activity of the prefunerary bustle. Even their speech becomes halting and sluggish as the reality of their situation takes hold. Liberated from parental

control and thrust into adult roles late in life, the sisters are unable to cope with the unprecedented challenge of their new freedom, and, in effect, fade out. Their unfinished sentences trail off into silence as they contemplate their uncertain future. The mood of the final episode is set by fragments of speculation such as "I was wondering if now . . ." and "Don't you think perhaps . . . ?" After the bustle and conflict in the roaring old man's final hours and stormy death, the sisters' tentative murmurs tell the story of the remainder of their lives. Lacking in guidance, devoid of substance, their days will drift away.

Balancing the comic vision with unflinching realism is a trick Mansfield must have learned from her long painstaking study of Chekhov. Chekhov's most memorable characters are comical in their ineffectuality, nervous tics, foolish opinions, and aimless gestures, all of which render them all too human from a psychological perspective. Josephine's most irrational utterance is the very thing that humanizes her, ludicrous as it is. Guilt-ridden and panic-stricken after the funeral, she bursts into tears and blurts to her sister: "We shouldn't have done it, Con!"

And Constantia, pale as a lemon in all that blackness, said in a frightened whisper, "Done what, Jug?" "Let them bu-bury father like that," said Josephine. . . . "But what else could we have done?" asked Constantia wonderingly. "We couldn't have kept him, Jug—we couldn't have kept him unburied. At any rate, not in a flat that size.". . . Josephine blew her nose. . . . "I don't know," she said forlornly. "It is all so dreadful. I feel we ought to have tried to, just for a time at least. To make perfectly sure. One thing's certain"—and her tears sprang out again—"father will never forgive us for this—never!"

The hilarious effect of this passage derives from the irrational childishness of a fully grown woman. Yet there is genuine pathos in her fears and quirks. The skill with which the author chips away at the adult protective shells of the spinsters Constantia and Josephine to unearth the quaking children Con and

Jug lies at the very heart of her finest character studies. These are real people, predictable products of a certain kind of inadequate rearing and emotional starvation. They are guilty, frightened, immature, and entirely credible. As characters, they are a far cry from the one-dimensional characters Mansfield drew in the *Pension* sketches as her only revenge against the national character of her "captors" during her confinement.

In this period Mansfield was as psychologically sound in her portrayal of the very young as she was of the ineffectual elderly characters in an environment that freezes out the two marginal elements. "The Young Girl" is a minor story, but handled in great detail, about a pretty adolescent, caught between her young brother's patently childish world of ice-cream parlors and her mother's forbidden world of gambling casinos during a Riviera holiday. The girl's petulance at being barred from the glamorous pursuits of her elders and being forced into the company of her docile small sibling is caught in two illustrative scenes. The first shows her chagrin and humiliation when she is barred from the casino and obliged to accompany her brother to the despised tea shop. She is rebellious and contemptuous. She flaunts her "soft young body in the blue dress . . . like a flower that is just emerging from its dark bud." She whips out the tools of her new maturity—a compact and a lipstick—and powders her perfect nose and rouges her rosy lips in defiance of all her heartless elders. The second scene shows her other aspect, the vulnerability of the child still intact within the burgeoning woman's body. Taken to a tea shop in compensation for being ousted from the casino, she is placated by her elders with chocolate and "little melting dreams" of pastries, which she devours even as she scorns them. Nature will have its due. Although she will deign to accept only the most ethereal of nourishment—tangerine ice to be eaten with tiny silver spoons and miniature pastry cornets filled with strawberries—she is nonetheless bribable, avid for pleasure, if not of one kind, then of another, and withal, a healthy young girl with a growing girl's appetite for sweets. Her

"lovely nose" sniffs the perfumed air of the tea shop, and the irresistible chocolate glides down the flawless "white throat."

Mansfield's preoccupation with food in her stories has often been remarked. There is no doubt that like her master, Chekhov, she dwells on eating, menus, hunger and its appeasement, and detailed accounts of the food and drink at dinner parties. Chekhov's obsession with food in his stories "Oysters" and "The Siren's Song" is no more extreme than Mansfield's "pageant of sensible substantial dinners" that drifts across Miss Ada Moss's field of vision in "Pictures" or the "shameless passion for the white flesh of the lobster" Harry Young confesses to in "Bliss." But, as in Chekhov, the rituals of eating and drinking, the references to certain kinds of foods, such as "the green of pistachio ices" in "Bliss" and grapes "green and cold like the eyelids of Egyptian dancers," are intended to release larger information about the character than the literal simile suggests. Rites, landmarks, conflicts, and unaltering values are implicit within the food symbolism in Mansfield's stories. The melted miniature ice-cream house in the story "Sun and Moon" distresses a small boy and causes him to howl in so "unmanly" a fashion that he infuriates his father. The subject of this story is generational conflict. In "Bliss," a beautiful red soup chosen to dramatize the pale gray plates in which it is served is a symbol of the aesthetic harmony in Bertha Young's life that will end in disharmony and disillusion. In "The Dill Pickle" a young woman imagines a condiment so sour that it causes her to "suck in her cheeks," a sign of her keen imagination and her ability to imagine unshared experience, however acid. Death is symbolized by the broken cakes and dried-out leftover sandwiches Laura Sheridan carries to the house of mourning in "The Garden Party." Seeking gratification of some kind, characters in the stories eat, alone and together, foods that symbolize their nature and position. Ada Moss, common and down on her luck, craves a glass of "nourishing" stout. The fuming pubescent in "The Young Girl," frustrated in her inability to indulge in the forbidden glamorous

rituals of the casino, finally gives in to her appetite for some kind of pleasure, and wolfs down the despised ices, creams, and éclairs as a surrogate for unattainable emotional satisfaction.

Food, furnishings, clothing, and personal adornment are some of the meticulously handled details of Mansfield's character fiction that contribute lavishly to its psychological realism. Character in perspective is accomplished through another technique; each person is shown in at least two different lights. Both Miss Moss and Miss Brill are subjected to the scrutiny of others, Miss Moss by her landlady who sees her for the old trollop she is, and Miss Brill by the two lovers who, within her hearing, make fun of her "silly old mug" and her ratty fox fur piece. These revelations shatter illusions just as surely as the young girl's false notion of her maturity is pricked by her unceremonious ousting from the casino where only real grown-ups are allowed to play.

The attitudes of the characters are often at odds with their actual environment, their aspirations and limitations carefully juxtaposed. Two such cases, both involving old men, may be found in "The Fly" and "An Ideal Family." Each of the elderly men is a "boss," a success in business and a figure of authority. But as each story unfolds, each is seen from another perspective. In personal terms they are victims of their age, their society's values, and their own children. The old man in "The Fly" denies his humanity, while Mr. Neave in "The Ideal Family" questions the humanity around him. Each man is a variation of Stanley Burnell grown old, at the end of his forces and incapable of controlling his environment. The tragedy of the aged go-getter who has outlived his own authority has its inevitable logic as well as its natural pathos. The first "boss," the central figure of "The Fly," spoiled with power, is incapable of weeping for his dead son because the boy had disobeyed him and joined the army. He vents his accumulated frustration in a brutal act of drowning a struggling fly in a drop of ink as he sits alone at his desk. The second, a man of equivalent wealth and position, the head of "an ideal family," is shown at the moment of his failing strength,

dressing for dinner with his family but shunted to the sidelines by his preoccupied wife and his self-indulgent children.

Each profile is accurately drawn and devoid of sentimentality. The elderly brute drowning the struggling fly even as he admires its pluck for surfacing each time but the last, is a realistic portrait of a man whose rage must be relieved because his sorrow goes unpurged. The fatigued old businessman of the second story dozes away in his room, unnoticed as the dinner party goes on below without him. He has paid for the bounty enjoyed in the splendid dining room but his presence at the board is no longer required nor welcome. All the while dreams and reality merge in his confused state as he is caught between fading life and imminent death but participating in neither.

Although these two stories are not dream stories, Mansfield makes use of the dream in both for the purpose of perspective. Psychological realism derives from examining the inner life, in these cases presented in the form of reveries. The boss in "The Fly" dreams of his beloved dead son just before his savage attack on the insect. Old Mr. Neave in "The Ideal Family" has two opposing dreams: the past, in which he feels the soft warm arms of a vanished young girl about his neck—the girl he should have married; and the future, his vision of a withered old man painfully climbing steps leading to infinity. Both dreams are truthful interpretations of his unrealized goals and his wearisome sterile achievements.

The flashback is another version of the dream. It shows the past, often halcyon in recollection, in contrast to the grim present. In "The Fly" the photograph of the boss's dead son on his father's desk is a recurring image that stirs up memories of the painful vanished past. The young fellow's sunny disposition is recalled as a symbol of the old man's unrealized aspirations, but the serious expression on the boy's face affronts his father, who denies his son had ever looked like that. His rage at the cruel tricks of fate, coupled with his guilt in not being able to remember his beloved son's facial expression, finds relief in his

sadistic murder of the helpless fly. Still, after the corpse is disposed of, he cannot find surcease. Instead of cathartic relief, he is seized by despair. The flashback to his son's untested youth has activated but not assuaged all the dormant repressed grief and anger in the impotent old man.

To the discomforts and idiosyncrasies of the eccentrics, victims, and outcasts in her stories, Mansfield brings an amalgam of authorial tolerance, humor, and compassion. The point of view in "The Fly" and "The Ideal Family" are cases in point. But for neurotics, the author wields a rapier. There is a world of difference between the insecure Reginald coming courting in "Mr. and Mrs. Dove" and the selfish spoiled Monica Tyrell in "Revelations." The tone in the latter story is set in the first sentence: "From eight o'clock in the morning until half-past eleven Monica Tyrell suffered from her nerves." The point of view is entirely subjective, but the reader is aware of Mansfield's moral presence as surely as he is of Henry James's stern judgment of the egotistical John Marcher in "The Beast in the Jungle" or of Chekhov's contempt for selfish Olga in "The Grasshopper." Monica Tyrell is a neurotic, and as such earns her creator's unmitigated scorn. Her story is told in gestures more than in episodes, each moving the story forward with inexorable logic to its inescapable conclusion. The heroine's gestures of "suffering" at the slightest irritation to her delicate nerves—the banging of a shutter; the ringing of a telephone; the pull of a hairbrush through her pampered tresses—cause her to press trembling fingers to pained eyes. In short, she is too fragile a flower for the indignities of everyday life. Anguished apostrophes such as "Oh, if it were as simple as that!" accompanied by pained dismissing gestures, shut out illness, poverty, and similar catastrophes from her luxurious boudoir.

But life insists on intruding, in spite of a well-regulated well-staffed household. Although he knows that his wife cannot face the morning hours, Monica's heartless husband has been thoughtless enought to send a telephone message asking that she

join him for lunch. This burden entails a more grievous one, a mandatory morning visit to the hairdresser on a raw windy day that frazzles her nerves beyond endurance. The crisis takes shape the moment Monica enters the perfumed precincts of the beauty shop. She senses, with the unerring instincts of the master narcissist, that the usual muted sycophancy of the elegantly appointed salon is off by a shade. A barely identifiable pall hangs over the establishment. Her hairdresser tugs at her hair and fails to remark on its beauty and sheen. When she finally discovers, not through any sensitivity or concern, that her hairdresser's small daughter has just died, she flees in panic. She experiences an unprecedented impulse to send him flowers as she passes a florist in her cab. In a pleasurable reverie she imagines a bouquet of white lilies and pansies tied with white ribbon and her sentimental accompanying note glorifying her pain at his bereavement.

The vignette ends with a swift denouement that captures the selfishness of the neurotic. Moved by her generous impulse, Monica taps against the window just as her cab passes the florist. But the driver does not hear, and "anyway, they were at Prince's already."

The neurotic's inability to act, to think things through, to progress beyond narcissism to compassion, is manifest in the story's mode of narration. The breathless highly agitated style is formed by elliptical sentence structure, incomplete phrases punctuated by dashes to dramatize Monica's inability to sustain a thought, and irritated gestures of dismissal. Mansfield does not trouble to comment on the ludicrous aspects of Monica's resentment of being put upon by an inconsiderate spouse who requests her company for lunch. Her self-absorption juxtaposed against the real but contained grief of the bereaved hairdresser speaks for itself, as does her craven flight from the scene.

"The Escape," the story that follows "Revelations" in the *Collected Stories*, is a continuation of the same theme—the selfish female of neurotic temperament in a merciless pursuit of

shelter and comfort. The same techniques prevail. A succession of internal monologues are truncated in midsentence as the character's restless thoughts skitter from one internal complaint to another. An undercurrent of whining is carried by a deft vocabulary—words like "hideous," "idiotic," "ridiculous"—when the woman takes stock of the people who have been put on earth to cushion her person and expedite her needs. In contrast, the character of the demanding woman's husband emerges as fine, generous, and trusting through her interior monologue:

It was his fault, wholly and solely his fault, that they had missed the train. What if the idiotic hotel had refused to produce the bill? Wasn't that simply because he hadn't impressed upon the waiter at lunch that they must have it by two o'clock? Any other man would have sat there and refused to move until they handed it over. But no! His exquisite belief in human nature had allowed him to get up and expect one of those idiots to bring it to their room.

Her veils, scented handkerchief, silver purse, and phials of pills, the ammunition of the neurotic, are contrasted with the world about her, an impoverished area in the Mediterranean where she has been convalescing. Her insularity rejects the baby held up by its proud mother for the inspection of the fine English lady. All she can see is its "awful, awful head." The flies circling the peasant houses, the sunburned carbuncled neck of the cabman, and "the disgusting, revolting dust" are affronts to her sensibility. Even the gift of flowers brought by the local urchins is rejected. She heaps contumely upon her good-natured husband who offers the children a few coins for their goodwill. In a temper, she flings the bouquet from the carriage.

The title of the story carries a double meaning, just as "Revelations" does in the preceding tale. Literally, the escape is the invalid woman's, told from her point of view during her exodus from the spa. But the story ends in a sudden shift in the narrative voice. As his wife flounces from the carriage to retrieve

a fallen parasol, the narrative is continued by the victimized husband, who is left with the cab to await her return. The emotionally exhausted man sees in his mind's eye "an immense tree with a round, thick silver stem and a great arc of copper leaves." He is taken by surprise, because he had been envisioning himself as a bleached skeleton buried in the valley below. From the silent silvery center of the magical tree he hears the soft full voice of a woman singing mellifluously and without strain. He is experiencing an epiphany that frees him from the shrill neurotic to whom he is yoked. Even after his return to England, the vision of the tree persists, offering him continued escape from her nagging presence. The memory of the charmed tree in its animistic power is similar to the erotic flowering of the pear tree in "Bliss" and the mysticism of the aloe in "At the Bay."

As unpleasant as the neurotics are in these stories, none can equal Raoul Duquette in "Je ne parle pas français," Mansfield's longest story after "Prelude." Briefly, its plot, told entirely through flashbacks, is a tale of moral corruption. Duquette, the narrator, exposes his despicable character through an event in which he is only an accessory. The episode itself is recalled through an accidental reminder to the young man as he sits idly in a café and picks up a pad on which someone had scrawled "*Je ne parle pas français*." He remembers that the same phrase had been spoken by a young English girl known only as "Mouse," perhaps because of her long snug gray fur-trimmed cloak, hat, and muff. She had been brought to Paris by Dick Harmon, a young English writer with whom Duquette had struck up an ambiguous, possibly homosexual friendship. When she had first met Duquette, she took his hand and murmured, "*Je ne parle pas français*." She plainly needed protection, but within a few weeks was abandoned first by her lover and then by Duquette, who had promised to see her through. A self-confessed cynic and a pimp by profession, he admits being haunted by poor Mouse as he sits in his usual place arranging for a female companion for some "dirty old gallant."

The first paragraph is pure Toulouse-Lautrec, a graphic depiction of a seamy working-class café. As Duquette the pimp lounges in his booth he notes the "grey, flat-footed and withered" old waiter "in his far too long apron," smearing over the table with a "three-cornered dip of dirty napkin," or "pouring a glass of familiar purplish stuff with a green wandering light playing over it." Madame, the *patronne*, "is thin and dark, too, with white cheeks and white hands. In certain lights she looks quite transparent, shining out of her black shawl with an extraordinary effect."

Passages such as these are reminiscent of Lautrec's highly charged selective portrayals of the world of dance halls, brothels, and cafés, whose denizens come close to caricature. In this story Mansfield seems to be intent, as the painter was, on telling the "truth" about urban life through dramatic portraits intensified by a shawl, a hat, or a splash of color. She is equally preoccupied with the effects of light, painting the "thin dark girls with silver rings in their ears" against a backdrop of coarse workmen "all powdered over with flour" lounging against the bar. Through the window "one could just see the shapes of horses and carts and people, soft and white, moving through the feathery air." As the dusk thickens, the images seem to disappear in the enveloping gloom, much as in Monet's Rouen cathedral, painted variously through mist or snow. In the darkening café, Duquette fancies he sees the departed Mouse as a "soft bundle moving . . . through the feathery snow." The melancholy mood is determined by the fading light and hazy atmosphere.

Although this lengthy story is unsatisfactory because it fails to tie up a number of loose ends, it is a fascinating piece of "art," notable for its attempt to do with language what the Impressionists and Postimpressionists were doing with brush and palette. This is Mansfield's most "painterly" story, its aesthetic effects calculated, not incidental. That she was familiar with the work of the painters cited, as well as Cézanne, Manet, Matisse, and the others, is beyond conjecture. She frequented the galleries in

London and attended and remarked in her letters the first Postimpressionist exhibition at the Grafton Gallery in London. The exhibit made such a profound impression on her that she wrote to her friend Dorothy Brett a dozen years later that the paintings "taught [her] something about writing which was queer, a kind of freedom—or rather, a shaking free." She began writing "impressionistic" exercises in her scrapbook, translating the pictorial effects of the painters into metaphors of light, shape, and immediacy of impression:

There was no sound in the house any more nor any light save where the moon shone on the floors and ceilings, on the dismantled supper table, gleaming on the mirrors and fading flowers. Silence hung over the garden, but the garden was awake. Its fruit and flowers filled the air with a sweet wild scent. White and grey moths flew over the silvery branches of the syringa bushes. On the dark camellia trees flowers were poised like white and red birds.

In other exercises she shows that she is searching, as Cézanne did, for arbitrary arrangements of line and form to give coherence to related shapes and colors of objects strewn on the table:

She bent her head, gazing with half-shut eyes at the white ring of the cup and the white ring of the saucer, the round white shape of the pot and jug, and the four crossed pieces of sugar on the table, at the cigarettes spilled out of the yellow wrapper.

"I want to reach that state of condensation of sensations which produces the picture," the painter Matisse wrote in 1908. Mansfield was aiming for the same visual initiative in 1918 when she began "Je ne parle pas français." Duquette produces just such a picture as Matisse envisioned with his self-portrait, which is a distillate of his corrupt and exotic character in a few phrases notable for "condensation of sensation":

"I am little and light with an olive skin, black eyes with long lashes, black silky hair cut short, tiny square teeth that show when I smile. My hands are supple and small. . . . I am like a woman in a café who has to introduce herself with a handful of photographs. 'Me in a chemise, coming out of an eggshell . . . ; me upside down in a swing, with a frilly behind like a cauliflower.' "

Later on one sees the "Japonais" influence in Whistler and van Gogh in his continuing self-portraiture: "It was early morning. I wore a blue kimono embroidered with white birds and my hair was still wet; it lay on my forehead, wet and gleaming." There are, as well, overtones of Degas, who can capture a gleam of pearl in a dancer's ear or the texture of velvet ribbon around her throat. The imagism in Ezra Pound's translations from the Chinese poet Li Po is evident here also. Mansfield was alert to all the new movements in art, particularly those abounding in visual effects. That she was self-conscious and calculating in her painterly techniques in this daringly conceived and executed story is apparent from her own analysis of her craft within the story. In the cab, Duquette insists on taking the jump seat facing his friends, because he wished to see their faces through "the occasional flashing glimpses" of the "white circles of lamplight. They revealed Dick, . . . his broad hat shading him as if it were a part of him—a sort of wing he hid under." The play of shadows on a face, the attitude of a reclining body, the figure thrown into relief by the light of the lamp against the dark, tell an impressionistic "truth" about the narrator-artist's perception of reality more revealing than the most detailed line-for-line rendition. Mouse, sitting next to Dick, is captured by the same artist, "her lovely little face more like a drawing than a real face . . . against the swimming dark."

The suggestive imagist touches instead of the "correct" drawing revered by the Academy painters succeeded in the immediacy and emotional repercussion sought, so that each time he looked at her "it was as if for the first time":

She came upon you with the same kind of shock that you feel when you have been drinking tea out of a thin butterfly cup and suddenly, at the bottom, you see a tiny creature, half butterfly, half woman, bowing to you with her hands in her sleeves. As far as I could make out she had dark hair and blue or black eyes. Her long lashes and the two little feathers above were most important.

Duquette's sense impressions are dependent on the moment, the light, and the emotional state of the observer. Like the Impressionist painters and the Imagist poets, Mansfield was seeking spontaneity through fleeting experience, sensory impact, and the captured moment that will evanesce as the light dims or diffuses.

Duquette's self-portrait is honest but repellent. As an acknowledged pimp and prostitute, he admits he lives through his senses. In a scene right out of Gauguin, he recalls having been kissed by his African servant until he became "very languid, very caressing, and so quickened, so sharpened, [he] seemed to understand everybody and be able to do what [he] liked with everybody." All his experience is defined in terms of the shapes and colors of objects about him. In one scene, against a background of cubist sofas, the guests drink red brandy before a homosexual seduction.

The climax of the story to which all Duquette's shocking allusions are leading is a confession:

I don't believe in the human soul. I have made it a rule of my life never to regret and never to look back. . . . Regret is an appalling waste of energy. . . . It's only good for wallowing in. . . . I have no family; I don't want any. I never think about my childhood. I've forgotten it.

Duquette, of course, is Mansfield's Underground Man, which should come as no shock, because her *Journals* are almost as full of Fyodor Dostoyevski as Chekhov. Although the Russian writer's famous *Notes from the Underground* begin with the words "I am a sick man. . . . I am a spiteful man. I am an unattractive man,"

a less shameless confession than the cynical Duquette's, its influence is apparent. Duquette's self-revelation betrays an excessive *amour propre*, which causes him to positively enjoy infecting others through his own self-degradation. Withal, he is as rootless and alienated as Dostoyevski's Man, capable only of sterile retrospection. Dostoyevski's Underground Man concludes with a backward glance: "Even now, so many years later, all this is somehow a very evil memory. . . . And why do we fuss and fume sometimes? . . . We don't know why ourselves." Mansfield's perverse hero ends on a similar note: "Even now I don't fully understand why. Of course I knew that I couldn't have kept it up." Both are studies of minds engaged in the process of ongoing self-evaluation but incapable of change.

The unsettling conclusion of "Je ne parle pas français" has Duquette promising to procure a "tiny little girl" for the "dirty old gallant"; it is clear that he has Mouse in mind, if he can find her. He then kisses his fingertips in a connoisseur's gesture of appreciation and lays his hand on his heart as a pledge of his honor. In that single act of unregenerate self-mockery, he abases himself, his victim, his client, and the traditions of culture and morality of the society that shaped him and which he exploits.

The fascination of this unpleasant story, whose plot is rudimentary and theme ambiguous, is its departure from anything else Mansfield ever wrote. Like Dostoyevski, she succeeds in showing a mind in a state of agitation, a complex process of thinking, voluptuous pleasure, and moral drift. Even on the occasional moment when Duquette expresses astonishment at seeing two people "really" suffer, he is distracted by Mouse's "quivering eyelids" and "the tears pearling down her cheeks" in a novelistic sensibility rather than human compassion. He actually scrutinizes his own coldheartedness and moral opportunism with the scrupulous honesty one expects from the writer in the objective detachment dictated by his craft.

Duquette is an unsettling composite portrait of a modernist hero, one part alienated man in the Russian confessional tradi-

tion, one part gigolo straight out of the French novels of Colette. His pouting mouth, "kept" aura, and general androgyny are reminiscent of the petulant Cheri in Sidonie-Gabrielle Colette's stories of sexual exploitation. The similarity between Duquette and Cheri is not surprising in light of Mansfield's voracious reading of Colette's fiction and her self-declared identification with the French writer. Mansfield's biographer Jeffrey Meyers claims she identified with Colette because the latter was so "independent, innovative and impulsive," everything Mansfield wished to be, but it is just as likely that she was taken with Colette's open treatment of sexuality and her relationship with her husband, the managing M. Willy, which she imagined bore some resemblance to her own relationship with Murry.

Owing much to so many sources of art and literature, "Je ne parle pas français" emerges as Mansfield's only story with a truly "modernist" sensibility. Would she have evolved into a consistently modernist writer had she lived long enough to develop in that direction? If by "modernist" it is understood that life is little more than a process of being without purpose or value, and that existence comprises sensation rather than societal standards, then "Je ne parle pas français" was clearly moving in that direction. If she had gone on to develop this philosophical dimension in her fiction, she might have found her own distinct modernist voice in the wake of this first derivative piece. This one story, however, must be seen as a departure. She touched on themes never before considered in her fiction: personal estrangement from accepted societal standards; sexual ambivalence in pursuit of personal gratification; and a pervasive pessimism expressed through debased human values.

6

The Urewera Notebook: The Wilderness as Source

In 1916 Mansfield confided to her *Journal* her wish to write about her New Zealand roots: "Now—now I want to write recollections of my own country. Yes, I want to write about my own country till I simply exhaust my store. Not only because it's a sacred debt that I pay my country . . . but also because in my thoughts I range . . . all over the remembered places. I am never far away from them. I long to renew my writing."

She had, in fact, done just that on a modest scale some years earlier when she was a girl of nineteen, during a month-long camping trip to the central region of the North Island with a party of friends. The year was 1907. Ian Gordon, the editor of the journal that became *The Urewera Notebook*, observes in his introduction, "In a few years it was going to lead to the great New Zealand stories of her maturity."[1]

The *Notebook* should be scrutinized on its own merits, not merely as a source of stories dealing with native New Zealand life, but first because it is unified in content and theme as her other journal and scrapbook are not, and second, because it contains fine descriptive writing that would later undergo light polishing and be incorporated into "At the Bay." *The Urewera Notebook* shows Mansfield as a lyric poet singing the praises of the North Island wilderness with the imagery of a Colette painting word pictures of Provence. A good example is the passage

describing the splendor of the rugged mountain road to Mataatua:

From this saddle we look across river upon river of green bush then burnt bush russet colour—blue distance—and a wide cloud-flecked sky— . . . A green mound looking over the valley—the air—the shining water—the sheep swift and terror-stricken flee before us—at the head of a great valley the blazing sun uplifts itself—like a gigantic torch to light the bush. . . . It seems to breathe the full deep bygone essence of it all—a fairy formation of golden rings—then rounding a corner we pass several little whares [Maori huts] deserted—and grey—they look very old and desolate—almost haunted.

Much of the *Notebook* is written in fragmentary unpunctuated prose such as this, but the jottings are a kind of literary impressionism (as distinct from the painterly Impressionism discussed in the preceding chapter) that the novelist Ford Madox Ford defined as "the rendering of impressions on our brains in a manner true to life itself." In the *Notebook* Mansfield achieves her effects through a fusion of the senses. Color, texture, sound, and tactile stimuli are recorded simultaneously. As in all impressionism, pictorial or literary, the mood is suddenly evoked and changes swiftly as the light or landscape alters. Color is an index to the mood:

There is the River—savage, grey, fierce, rushing, tumbling—madly sucking the life from the still placid flow of water behind—like waves of the sea like fierce wolves—the noise is like thunder—right before them the lonely mountain outlines against a vivid orange sky—the colour is so intense that it is reflected in their faces, in their hair—the very rock on which they climb is hot with the colour—They climb higher—the sunset changes—becomes mauve—and in the waning light all the stretch of burnt manuka is like a thin mauve mist around them—A bird—large and widely silent flies from the river right into the flowering sky—There is no other sound except the voice of the passionate river.

Passages such as these offer some clues to Mansfield's purposes at the time. Her capitalization of the "river" at the beginning of the paragraph indicates that she is assigning to nature energy and force. Human response is governed by nature's will, and alters as the landscape changes and the light intensifies. This is the impressionism of Stephen Crane's "The Open Boat," in which the destiny of a shipwrecked crew is mandated by the "seven mad Gods of the sea," and human perception is limited by the boundaries of the sea and the frame of the far-off horizon. When Mansfield describes the "desolate whares" as determining the "tragic" mood of the deserted bush, and the "intense stillness" of a swamp as "almost terrible," she is recording nature's imprint on human apprehension. The *Notebook* is an almost perfect illustration of "the basic canons of impressionistic writing," according to the definition of Italian critic Sergio Perosa, who lists among its attributes "the apprehension of life through the play of perceptions, the significant montage of sense impression, the reproduction of chromatic touches by colorful and precise notation, the reduction of elaborate syntax to the correlation of sentences, which lead up to a sketchy, and at the same time evocative, kind of writing."

Was the style of the *Notebook* accidental? Did Mansfield know that she was writing impressionistic exercises? We have no confirmation from her, but Gordon says that it ought to be regarded as "a key text for an understanding of the young KM. . . . It is a writer's notebook, analogous to an artist's sketchbook. . . . The writing, though in sketchbook form, is deliberate and careful, at times showing signs of stylistic revision." The overall effect of the *Notebook* as a whole, conscious or not, is decidedly impressionistic.

The expedition to the Urewera served as raw material for some of the settings of Mansfield's early fiction, most notably "The Woman at the Store." This story, which Murry published in 1912 when he was editor of *Rhythm*, was so closely based on *The Urewera Notebook* that Gordon surmises "she must have had

The Urewera Notebook open before her as she was writing." The setting is a composite of descriptions of the plain between the Waipunga River and Rangitaiki. The characters are versions of the rough colonials she had met and liked. Her sharp ear picked up the cadences and colloquial vocabulary of the native speech, which she transcribed faithfully in the story, one of her most fully plotted narratives, complete with a surprise ending. It is a story of murder, revealed gradually against a background of the primitive bush country, where the pervasive heat and swirling dust provide a psychologically appropriate atmosphere of unremitting tension against which a tale of mistreatment and violence unfolds. The interspersed allusions to an occasional sensuously suggestive orchid and manuka in the' parched plain prepare the reader for explosive emotions underlying the bare unrelieved tussocky landscape.

The first paragraph is unusually effective in establishing and then controlling the mood of the developing story. It is actually a seamless smoothed-out version of the unpunctuated sketchy notes in the *Notebook* recording the young author's reactions to her trek from Rangitaiki to the Waipunga:

All that day the heat was terrible. The wind blew close to the ground; it rooted among the tussocky grass, slithered across the road so that the white pumice dust swirled in our faces, settled and sifted over us and was like a dry-skin itching for growth on our bodies.

Against this ominous background of stifling heat, swirling dust, and slithering wind Mansfield tells an uninflected story about ordinary uncultivated sheepshearers living in isolation and squalor, concealing a deed of violence provoked by their hard dehumanizing existence. The narrator is one of three males on horseback in country much like the Urewera. Jim, one of the party, remembers from a previous visit a mean little shanty where they might stop for provisions and overnight lodging before resuming their trek. They are met, ominously, by a woman

carrying a gun. She is a frowzy toothless slattern, a far cry from the blond young girl he recalls from his earlier visit. Four years had passed, and she no longer resembled the tempting little barmaid who had married a strapping sheepshearer, and who had confided to Jim that she knew 125 ways of kissing. Now she is alone except for a mangy dog and an undersized brat of a female child who spends her time drawing crude figures on scraps of paper.

The story evolves with relentless naturalistic inevitability. The woman complains of her harsh fate and rails against her husband who has gone off sheepshearing; the child whines and "bleats" like the sheep. She threatens to draw something her mother has forbidden. Lightning flashes, flies circle the cramped room, the men drink, and one of them begins to itch for the adjacent female flesh, no matter how repellent.

The closely kept secret unfolds in a perfectly natural way. The child is enraged at being cooped up with the two men while her mother goes off with the third after thrashing the child. In a fury, the little girl draws a picture of her mother shooting her father and burying him in a hole. Mansfield ends the gruesome story dispassionately. The men leave as they had come, noting that as they looked back, "a bend in the road and the whole place disappeared."

Although Murry had not yet met its author, he said that "The Woman at the Store" was the best story that had ever been sent to *Rhythm*. It was also an unusual type of fiction for Mansfield at any time in her creative life. In its powerful naturalism it resembles nothing so much as Stephen Crane's "The Blue Hotel." As the erupting violence in Crane's tale of explosive action is a function of a seething atmosphere, in this story the revelation of the murder committed and concealed is heralded by oppressive heat, crackling thunder, and dehumanizing loneliness. The sojourning men sense the tension and are prepared psychologically for the inevitable shock. Moments before the revelation, they leave the shelter of the shack, go out to the

paddock with a lantern to feel the wind lashing their faces in an unnatural light "as though a bush fire was raging." They become emotionally attuned to a harsh land in which passions boil and violence may erupt. After the awful revelation, the heat lifts, the storm has done its work in wetting the blinding pumice dust, "white clouds float over a pink sky," and the interlopers depart.

The narrator's point of view is achieved through carefully controlled imagery. Manuka bushes and wild orchids provide the hot colors of sensuality, while the thin line of blue smoke from the shack's chimney suggests aridity and desolation. A yellow dog lying across the doorstep biting fleas is a visual counterpart to the odor of cabbage suffusing the yard. In this grubby setting, the hot sun piercing through the ashen light symbolizes the violent emotions of the outbackers pushing through the grim ritual of grinding daily routine. Hot and cold colors, the purple manuka and slate-colored sky, "shrilling larks," and "slithering grasses" recreate the savage spirit of the New Zealand wilderness. Indoors, pages clipped from magazines depicting Queen Victoria's jubilee are pasted over the peeling walls, giving off an aura of shabby respectability. Pink paper draped over the mantelpiece is touching evidence of a clumsy attempt to bring some beauty into a stark environment.

In each frame of the story, a perspective is established for a particular portion of the narrative. In the beginning, the travelers on horseback come into a country they do not understand but are prepared for by harsh weather and grim landscape. The perspective changes as they approach the store, and the native inhabitants create their own emotional environment through their clothing, speech rhythms, and a shared history that exclude the visitors, who can only guess that the unremitting heat has made them "balmy." The hostility of their hosts is interpreted as a quirk of nature, a delusion that is abetted by the alien territory in which they find themselves. "Sitting alone in the hideous room I grew afraid," the narrator reflects, "as though the savage spirit of the country walked abroad." His terror is reminiscent of the

Swede's fear of his alien surroundings in Crane's "The Blue Hotel" while the blizzard rages outside.

From a casually overheard quarrel in the Rangataiki Hotel, which Mansfield jotted in her *Notebook* ("Woman and daughter—the man—their unhappiness—forgive Lord—I can't"), Mansfield fleshed out this meticulously detailed accurate evocation of life in the Urewera outback. Even her notes on the broken old "Blucher" shoes worn by the woman find their way into the story to emphasize her isolation from civilization. It is a small detail, and uninformative to the modern reader who may not know that bluchers are men's shoes, but to Mansfield's contemporaries, who surely did know, the detail served to create some sympathy for the nearly deranged woman in her terrible isolation. That Mansfield troubled to note the bluchers in her *Notebook* and used the small detail in her story ten years after she had made the note tells the reader that she was indeed destined to be a disciple of Chekhov's. In writing description, the Russian author insisted "one ought to seize upon the little particulars, grouping them in such a way that, in reading, when you shut your eyes, you get a picture." The details of setting, all scrupulously recorded in the *Notebook* jottings so many years before Mansfield actually wrote the story, make a clear picture of the undeveloped New Zealand countryside. Against this background of cultural privation and psychological turmoil, the gradual revelation of violent action and its ensuing drama is natural and credible. The yellow flea-ridden dog, the flowering manuka in the acrid dust, the flickering light indoors and bolts of lightning outside, are clearer indexes to states of mind than any attempt at discursive analysis would be.

Mansfield's control of her subject in "The Woman at the Store" comes of her obedience to Chekhov's injunction to pay strict attention to selected detail, to "avoid depicting the hero's state of mind," and to refrain from inventing life outside the author's own experience. "Do not invent suffering you never experienced, and do not paint pictures you never saw," he cau-

tioned his brother Alexander, a hopeful writer himself, in 1886.[2] There is not a scene in "The Woman at the Store" that Mansfield had not witnessed in her wilderness trek, nor a character whose like she had not encountered. Although the plot, dialogue, and mood of high drama in the story are the fruit of her creative imagination, they are true in the sense that she saw the world in which they unfolded firsthand and preserved her memory of its components to draw on in the future. Ten years later, she would establish an authentic emotional and cultural background for the crime and its revelation through her choice of salient details of that remote primitive outpost to which she, like her characters, had sojourned. Because she met and was impressed by its rough hardened inhabitants, her narrative has a dual perspective. Its episodes bear the disparate points of view of the intruders and settlers. Both are persuasive. The outsiders have stumbled into something outlandish that the insiders are at pains to conceal. Tension, the predominant mood, is a natural consequence of confrontation between the civilized and the primitive; in technical terms, it is a triumph of polarity.

Other stories that owe setting and content to the *Notebook* are "How Pearl Button Was Kidnapped" and "Millie," a lesser version of "The Woman at the Store." "Millie," like its better-executed version, reflects the unappealing aspects of the trek, those times when the idealistic young Mansfield comes to depressing towns such as Rotorua and records that she is "ill and depressed" in the latter part of the *Notebook*. "Disgusted and outraged" by the poverty of the people living in the gray dust, she came to the conclusion that even good people will be misshapen by the "horrible" conditions of their lives. The story is notable more for its evocation of the hard life in the outback than for its plot, which is more successfully handled in "The Woman at the Store." Its value lies in its sympathetic character study of a woman who is worn and toughened by the rural plains country, but still retains a spark of compassion for a poor young outlaw who is being hounded by a posse of vigilantes for his presumed

murder of one of the ranchers. The flicker of humanity in the breast of the worn defeated woman is snuffed out, however, at the first sign of the chase. Abandoning her intuitive protectiveness for the hunted prey, the childless woman, who for a moment felt an instinctive compassion she might have felt for her own child, follows the hunt, flailing and leaping on the dusty road with the posse.

Mansfield's method here is one of accretion. She piles detail on detail to create the impression of a harsh life that must generate inexorably harsh behavior. The inevitable fate of the young man who hides in Millie's barn is sealed from the beginning, although the woman's heart is briefly touched by his youth and vulnerability. The men of the plains who hunt him down are as much victims of the socially deterministic forces that have shaped their savage natures as is the trembling hunted victim of their savagery. The story's point of view is entirely naturalistic in its demonstration of attitudes and values shaped by external forces, in this case the hardships of primitive living conditions.

In contrast, "How Pearl Button Was Kidnapped" is a fanciful little tale recounting an imaginary abduction of an innocent little girl by a band of gypsies. It is told guilelessly from the child's point of view, who sets the infantile tone through phrases such as "sunshiny day" and "house of boxes." The tone is too self-consciously adorable, even granted the author's striving for an authentic childlike point of view. Even the name "Pearl Button" evokes a wee fairy-person engaged in a fantasy of wish fulfillment to carry her away from her orderly House of Boxes to an enchanted kingdom. The wind playing "hide-and-seek" in the yard and blowing Pearl Button's pinafore frill into her mouth is too patently an arch contrivance to be persuasive. But the description of the Maori country is unerring. The gypsy encampment is taken directly from *The Urewera Notebook* as is the surrounding countryside: "First fields of short grass with sheep on them and little bushes of white flowers and pink briar rose baskets—then big trees on both sides of the road." It is a picturesque setting for a

fairy tale about sanitized gypsies kissing the dimples in Pearl Button's fingers to soften the "kidnapping" into a dream sequence of escape from reality into a never-never land.

As an allegory "Pearl Button" is faulty. Although the child asks the gypsies (Maoris in the *Notebook*): "Haven't you got any Houses of Boxes? Don't the men go to offices? Aren't there any nasty things?," the "moral" is too transparent and lacking in subtlety. The portrayal of the land of make-believe, in this story a fusion of gypsy-Maori encampments, and the real world of the middle-class white colonial New Zealand family, sentimentalizes the first and recoils from the second. "I am so sick and tired of the third rate article," Mansfield wrote in the *Notebook*. "Give me the Maori and the tourist but nothing between." She is captivated by the laughing carefree grown-ups and the "little naked babies holding on to them or rolling about in the garden like puppies" in a species of back-to-nature fantasy, complete with noble savage. She writes of a pretty girl with long dark hair who eats natural foods from the floor. The child is stripped of her pinafore and shoes and walks barefoot on the green grass, freed from the badges of her civilization.

The *Notebook* contains the raw material for the child's prelapsarian state in her Edenic setting:

The road to Te Whaiti—Meet the guide—Wild strawberries—the pink leaved ferns—Matai—Lunched at a space in the bush cut through a tree—and then by devious routes we came to the pah [village]—it was adorable—no English—then a charming little place—roses and pinks in the garden—Through the doorway the kettle and fire and bright tins—the shy children.

When some years later she confided to her *Journal* her need to repay her "sacred debt" to New Zealand, she must have been recalling that brief visit to the unspoiled country of the Urewera in the company of its native population:

Ah, the people—the people we loved there—of them, too, I want to write. Another "debt of love." Oh, I want for one moment to make our undiscovered country leap into the eyes of the Old World. It must be mysterious, as though floating. It must take the breath. It must be "one of those islands. . . ." . . . But all must be told with a sense of mystery, a radiance and an afterglow.

The Urewera Notebook is as close to poetry as Mansfield was ever to come. In her later life she was to confide to her *Journal*:

Then I want to write poetry. I feel always trembling on the brink of poetry. The almond tree, the birds, the little wood where you are, the flowers you do not see, the open window out of which I lean and dream. . . . But especially I want to write a kind of long elegy to you. . . . And lastly, I want to keep a kind of minute notebook, to be published someday.

This early *Urewera Notebook* actually contains some of the poetry she dreamed she would write someday. Her entries are a kind of poetic shorthand, its vocabulary image-soaked and concentrated, its moods highly colored and self-aware. She did write an actual poem in the *Notebook* called "Youth," which was infinitely less successful than an essay called "Vignette," in which she pays poetic tribute to the lakes "drowned in sunset," the "silver blue" mountains, and the "pale amber" sky of the Maori country. This extended prose poem pays tribute to the Maori who are in harmony with their environment through a highly charged portrait of a young Maori girl, "the very incarnation of the evening—and lo—the first star shines in her eyes."

When Mansfield confided to her *Journal* her intention to write a "kind of long elegy" to New Zealand, she did not realize that she had already done so in some small measure in the *Notebook*. She quibbled about the form her tribute would ul-

timately take, "perhaps not in poetry. Nor perhaps in prose. Almost certainly in a kind of *special prose.*" *The Urewera Notebook* is, in fact, a special kind of poetic prose as well as an invaluable guide to another New Zealand and a source for some of her native-inspired fiction.

7

Novels and Novelists:
The Writer as Critic

In April of 1919, Katherine Mansfield's husband, John Middleton Murry, was appointed editor of the weekly, *The Athenaeum*, which defined itself as a "Journal of Literature, Science, the Fine Arts, Music and Drama"—in short, an intellectual review. Murry then offered his wife the position of reviewer of novels, a critical task she performed until December 1920, when illness forced her to give it up. In 1930, seven years after his wife's death, Murry organized the reviews chronologically in a volume called *Novels and Novelists*, having decided that "any other arrangement would make meaningless her not infrequent allusions to books previously reviewed, or to her previous reviews of books." Murry was confident in his judgment that the reviews, taken together, "form a body of criticism unique in its kind," and regretted the omission of reviews of H. G. Wells, Arnold Bennett, and most particularly Katherine's longtime friend and occasional adversary, D. H. Lawrence. Murry gave no reason for the omission of those reviews, but it may be assumed he was denied permission to include them. The only reference to Lawrence is a note written in Katherine's copy of *Aaron's Rod*, which Murry entered at the very end of the collection as an indication of his wife's recognition of her colleague's genius.[1]

Mansfield's biographers have by and large either dismissed this aspect of her work as insignificant, or have taken the author's

word that it was drudgery undertaken for a meager but necessary stipend. Certainly, few people shared Murry's confidence in the "uniqueness" of his wife's critical judgment. Her biographer Antony Alpers complained that "one does not easily discover an aesthetic in Katherine's reviews," and bolsters his negative estimation by citing T. S. Eliot, "who is on record as saying she didn't have one." Jeffrey Meyers writes that Katherine hated the boredom of reviewing undistinguished books for ten pounds a month, an opinion borne out by Katherine's own complaint to Murry that "the books are rather difficult to do: they are *so bad*." Sylvia Berkman is more tolerant. Although she praises Katherine for her conscientiousness, she finds it a great pity that a writer of her talent should have wasted her effort on "ephemera."

Now that the dust has settled, the plain truth about Mansfield as critic is similar to the truth about all creative writers, from Chekhov to John Updike, who have acted in a critical capacity. Their reviews are often more interesting for what they reveal about themselves than about the writers they are judging. Seen in retrospect, a good deal of the material subjected to Mansfield's critical scrutiny proved in the course of time to be shallow and insignificant. But among the chaff there was some fruit. Her reviews of Somerset Maugham, John Galsworthy, Enid Bagnold, and Dame Rose Macaulay indicate that she had the ability to distinguish between trendy novels and fiction of quality. A sampling of her reviews demonstrates a carefully reasoned, if somewhat cautious, approach far removed from her perfervid *Journal* entries on literature or her superheated comments on books such as her gushing letter to Murry on John Forster's biography of Dickens. "It's ravishing," she declared, surely an ill-chosen description for an unspectacular if solid piece of biographical writing.

If in her letters and *Scrapbook* she occasionally shot from the hip, it should be remembered that some of her opinions collected in those volumes were made when she was very young. She was not self-indulgent in the *Athenaeum* reviews, which show mature

judgment and taste. If the reviews do not constitute a "unique" body of work, as Murry claimed they did, they are at the very least instructive in showing a fiction writer in the role of arbiter of her craft.

It is not surprising that Mansfield should have reserved her highest praise for Dostoyevski. She admired his writing almost as much as her revered Chekhov's. Her *Scrapbook's* 1916 entries are filled with allusions to and analyses of *The Idiot* and *The Possessed*.[2] It is no wonder then that she was to measure all other writers against the Russians, in whose writing she discovered depth of compassion, metaphysical dimension, and human comedy, as well as tragedy and candor.

Mansfield's review of "Some Aspects of Dostoevsky" on November 28, 1919, is one of the few examples of her critical approach to the short story, her own genre. Although her columns were primarily devoted to the new novels of her day, with some retrospective glances at historical figures such as Jane Austen, in this case she reviewed Dostoyevski's *An Honest Thief: And Other Stories*, a departure from her usual assignments. The review, a lengthy one, is valuable as a guide to the qualities she was trying to incorporate into her own work.

She begins with a hypothesis:

If we view it from a certain angle, it is not at all impossible to see in Dostoevski's influence upon the English intellectuals of to-day the bones of a marvellously typical Dostoevski novel.

As she goes on to imagine Dostoyevski's themes and characters transported to London from his small provincial Russian town, one knows whom she is talking about as the creative heir to the Russian: herself. She goes on in a leisurely manner to imagine the literary community stripped of the Dostoyevski influence. Although the master had been dead for almost forty years and his writing was out of fashion with her contemporaries, she imagines

serious young writers finding themselves "naked and shivering" if deprived of his warming influence.

The qualities she admires most in his writing are those very qualities she strove so mightily to introduce into her short stories. Dostoyevski was blessed with the "habit of describing at length, minutely, the infinitely preposterous state of mind of some poor wretch," provoking in the perceptive reader a mixture of tears and laughter. The story she dissects as a prime example of the polarity of tragedy and comedy in an ordinary man deluded by his vanity and forced to confront his *amour propre* is called "An Unpleasant Predicament." In its theme and character one can see the germ of some of Mansfield's own mature fiction, genre stories such as "Pictures" and "Miss Brill." Stories about ordinary people, in Mansfield's case women more than men, try to set up "this mysterious relationship with the reader, this sense of *sharing*" that she finds so poignant in the Russian writer's depiction of tailors, soldiers, and draymen—the focal characters in these sympathetic tales.

Although her estimation of no other writer comes close to her admiration for the Russians, she has some kind words to say for John Galsworthy's powers of "analysis and dissection" in *The Forsyte Saga*. She complains, however, that he falls short of Dostoyevski's ability to feed one's imagination through "mystery." "The Forsyte men are so completely life-size, so bound within the crowns of their hat and soles of their shoes, that they are almost less than men," she writes of *In Chancery*, one of the volumes in the series. Her criticism is directed towards Galsworthy's verisimilitude in portraying old James Forsyte in such meticulous detail that he stifles the reader's imagination. "Is it not amazing," she asks, "how he comes before us so that we see him, hear him, smell him, know his ways, his tricks, his habits, as if he were our grandfather?" Her own preference would lie in permitting the reader to sketch her character Miss Ada Moss in the story "Pictures" for himself with the help of some telling clues to her person—her varicose veins, her hat, and little else.

Mansfield believes that precise attention to detail—a kind of literary equivalent to connecting the dots in children's coloring books—is injurious to the imagination. The reader must be encouraged by the author to be creative. Some socially observant writers kill the reader's power to imagine and empathize. In her review of Somerset Maugham's novel *The Moon and Sixpence*, she admires the author's ability to re-create the painter's opposing environments of middle-class London, bohemian Paris, and exotic Tahiti, but takes him to task for his failure to show "something of the workings of his mind, . . . some comment of his on what he feels." All Maugham's considerable success in re-creating the social and cultural backgrounds for this authentic novel based on the life of the painter Paul Gauguin cannot compensate for his neglect of the hero's intimate dreams.

In her final *Athenaeum* reviews, Mansfield expresses similar ambivalence about Edith Wharton's novel, *The Age of Innocence*. While she admires the socially observant Mrs. Wharton's successful re-creation of patrician New York in the 1870s, she faults her for the pasteboard quality of her characters. In the novel's most sensitive scene—the parting between Ellen Olenska and Newland Archer, the unfulfilled self-sacrificing lovers—"not a feather is ruffled; their parting is positively stately." Mansfield, the disciple of Dostoyevski, is appalled. "But what about us?" she cries. "What about her readers? Does Mrs. Wharton expect us to grow warm in a gallery where the temperature is sparklingly cool?" The emotional and spiritual heat she found in the Russians is lacking in the American and British social realists. While she concedes that they are capable of turning out "fascinating, brilliant" books, she cannot credit them with writing great novels.

Some admiration is reserved for the experiments of Gertrude Stein for her syncopated "rag-time" rhythms, but she ends with a devout prayer that she not become a fashion. In the case of Joseph Conrad, she distinguishes between his occasional "fine economy of expression" and his unfortunate frequent tendency

towards prolixity. Her review of his novel *The Arrow of Gold* is astute. Because of the novel's discrepancy in style, she speculates that it has lain in the cellar for a long time after a number of false starts.

Mansfield reviewed Virginia Woolf twice—first on June 13, 1919, and then on November 21 of the same year. Her criticism is instructive for a number of reasons. First, the initial review is devoted entirely to "Kew Gardens," a short story and Mansfield's own literary genre. Second, the later review, this time of the novel *Night and Day*, is an interesting departure for Mansfield as critic. She takes the opportunity to compare her friend and colleague to Jane Austen, a writer for whom she felt whole-hearted admiration.

The first review is something of a curiosity. Mansfield is full of praise for "Kew Gardens," while at the same time she manages to say very little about it. Having conceded that Woolf must be distinguished from the other young writers of her day as an artist whose vision and style belong to an earlier age, she neglects to give the grounds for her perception. This is a disconcertingly gushing review, full of "uptown" prose about the author's tone:

It is strange how conscious one is, from the first paragraph, of the still sense of leisure: her story is bathed in it as if it were a light, still and lovely, heightening the importance of everything, and filling all that is within her vision with that vivid, disturbing beauty that haunts the air the last moment before sunset or the first moment after dawn. Poise—yes, poise. Anything may happen; her world is on tiptoe.

In spite of the critic's extravagant "appreciation," the story itself remains a mystery. Mansfield has managed to pay tribute to Woolf's special "quality," but she has neatly evaded her responsibility as a critic. It is tempting to think that she was earning Woolf's goodwill while at the same time she was beating her rival at her own game, slyly showing that she was capable of writing with Woolf's airy obscurantism.

The second review is an exercise in hypocrisy. Mansfield's private opinion of Woolf's novel *Night and Day* is vastly different from her published review. In a letter Murry she wrote, "I don't like it. My private opinion is that it is a lie of the soul." The letter is dated November 9, 1919, just after Murry had sent her the book for review. But on November 21, she wrote: "Yet here is *Night and Day*, fresh, new and exquisite, a novel in the tradition of the English novel. . . . We had never thought to look on its like again." She had succeeded in masking her distaste for Woolf's escapist literature in a world wracked by war by turning her private censure into public praise. Declaring that she never thought to find in that day and age, or "on the great ocean of literature a ship that was unaware of what had been happening," she commends Woolf for creating so exquisitely a "far away" world, "shut and sealed" from present reality. She compares its "leisurely progression," its "cultivated, distinguished, but above all—deliberate" tone and pace to the great novels of the great Jane Austen.

But if one has to hunt for the cavils, which do exist, in the sea of encomiums, the reason is clear. The *Athenaeum* was Murry's commercial venture, and he had to tread very softly in the presence of the literary lions whose works were being scrutinized by his ailing wife. Mansfield was franker elsewhere. For her true opinions, her letters and diaries are a richer source. For instance, her appreciation of Emily Brontë's poetry is based on her certainty that "it is not Emily disguised who writes—it is Emily." Oscar Wilde "is a Judas who betrays himself." In 1922 she confesses her "unfairness" to James Joyce, but concludes that his "vulgarity" and "commonness" still shock her and offend her sensibilities as would "wet linoleum and unemptied pails" in an untidy house. She has no such reservations about Marcel Proust, whose writing fills her with "exquisite rapture."

The new publication of *The Collected Letters* is an even richer trove of criticism than Murry's expurgated edition of 1929.[3] This first of several projected volumes covers the years 1903 to 1917,

introducing the reader to a precocious Mansfield. Some of her more amusing correspondence is in the form of letters to the editor of the magazine *The New Age*, and includes sly parodies of some of the popular literary figures of the day, including G. K. Chesterton, H. G. Wells, and Arnold Bennett. The year is 1911, Mansfield only twenty-three, but her parodies show an accurate ear and a wicked wit. Even a purely friendly letter to Bertrand Russell, the philosopher-mathematician, reveals that she subjected the minutiae of ordinary life to literary analogy: "Life seemed to rush in and out of my door like the teller of the tale in a Dostoevsky novel," she wrote from her Bloomsbury flat in 1916.

Her finest critical perceptions were probably those she applied to her own writing, particularly the "process" involved in her art. In 1917, she wrote a lengthy letter to her friend, Dorothy Brett, just after the Woolfs had taken the first pages of "Prelude," which they would handprint in their Hogarth Press. Mansfield, undoubtedly reminiscing about the "duck" episode in section 9 of "Prelude," discussed her "method" at length in the letter, arriving at a rationale for composition analogous to the painter Paul Cézanne's theory of the "spirit of the apples," which takes precedence over the literal fruit:

When I write about ducks I swear that I am a white duck with a round eye, floating in a white pond fringed with yellow blobs. . . . In fact this whole process of becoming the duck (what Lawrence would perhaps call this "consummation" with the duck) is so thrilling I can hardly breathe. . . . There follows the moment when you are *more* duck . . . than [the duck] could ever possibly be, and so you create [it] anew. . . . That is why I believe in technique, because I don't see how art is going to make that divine *spring* into the bounding outlines of things if it hasn't passed through the process of trying to *become* these things before recreating them.

In her literary criticism, about her own works or those of

others, her most valuable contribution is her insistence on authenticity of experience. Perhaps that is the reason she found Woolf's fiction inauthentic, and why, in spite of her reservations about her friend Lawrence, she was able to praise his novel *Aaron's Rod* for the depth of his feeling. In using the analogy of a tree to the book, she feels it to be "firmly planted, deep thrusting, outspread, growing grandly, alive in every twig." It is the quality she most responds to in the Russian novelists and it is the quality of integrity she most seeks to create in her own stories. It is the reason why prolific novelists such as Hugh Walpole, who demonstrate an "infinite capacity for taking pains," cannot win her critical approval in the *Athenaeum* review of October 15, 1920. In a carefully reasoned, not unkind review of Walpole's lengthy novel, *The Captive*, she lauds him for his "determination" but chides him for his failure of "inspiration." She deplores his method, which is "to amass information" and to fill his novel with characters and events. But, she complains, "no one observation is nearer the truth than another." In her opinion, all writers, herself not excluded, are most effective when they have an intimate relationship with their subject, when, as she said about Lawrence's fiction, they are "fed" by the book they have written.

8

Spheres of Influence:
A Critical Perspective

Katherine Mansfield's reputation has suffered more from her untimely death than did the legacy of other writers whose lives were also claimed at an early age by tuberculosis. Chekhov, for instance, whose stories were so influential to Mansfield, was judged to have fulfilled his promise. D. H. Lawrence and Henry David Thoreau, who died of the same disease, appeared to have completed the work they had undertaken although they died young. In Mansfield's case, however, there was always the sense that her voluminous body of short stories constituted a "prelude" to the larger opus that was never begun. She is even denied the classic justification applied to the untimely death of Stephen Crane, who died at an even earlier age, but whose end was explained as a consequence of romantic excess and willful self-destruction. Perhaps some of the onus for the critical community's judgment must finally rest with her. She alone, of the cited doomed authors, dwelled on her frustration in the volumes of her letters and later, in her *Journal* and *Scrapbook*. As her health failed, she was obsessed about her dwindling time, her precarious health, and her despair at her inability to realize her talent fully. Nowhere in the fourteen volumes of Thoreau's *Journal* can the reader find a single reference to his own health among the entries reflecting on nature, politics, culture, and history. Chekhov's enormous body of prose other than his stories and plays is

likewise free from self-reference. Perhaps by refraining from calling attention to projects still in the offing but destined to remain unfulfilled they escaped the reservations always applied to Mansfield's work.

Even so astute a critic as Frank O'Connor, having praised Mansfield's "Prelude" as "remarkable" and a "masterpiece" in his book *The Lonely Voice*, wonders whether she could have "exploited her own breakthrough into magic" as Joyce and Proust succeeded in doing. He speculates that death "came too soon" after some "tantalizing hints" of further development. The question he puts to himself, "Are they really works of art that could have given rise to other works of art and followed the law of their own being?," goes unanswered. Isobel Clarke, an early biographer, attributed Mansfield's relative failure of appreciation to a cultural preference of the reading audience of her day. "The English public does not encourage short stories," she wrote. "It prefers the novel, and for choice, a very long one." Apparently, writers such as Lawrence, A. E. Coppard, and Somerset Maugham, who began with the short story, lived long enough to become novelists of note and were thus exempt from disapprobation or from being regarded as literary lightweights or being stuck at a way station before reaching their ultimate destination as novelists. Mansfield never wrote anything other than the short story, and there are few indications that she intended to move beyond that form, which she mastered at an early age. And although she could very well join Crane in the category of excessive indulgence and self-destructiveness in the romantic nineteenth-century tradition, she is firmly entrenched in literary history as a twentieth-century figure, and is therefore denied the flaming stamp of excess, even though her life bore ample witness of it. Her work must therefore be judged on its merit as it stands, and must be evaluated according to its contribution to the genre of the short story, without the indulgence of a hypothetical literary output of a longer life. Her stories must stand on their own, as do Guy de Maupassant's, and in our own day, the short

stories of the *New Yorker* writers, many of whom have exclusively written short stories for decades. The emergence of the gifted short story writer of the twentieth century, craftsmen such as Peter Taylor and William Trevor, has justified the genre as independent of other literary forms. Today the author need no longer defend himself against the charge of miniaturizing or for preparing for something larger, like a novel.

Mansfield's legacy has been a manipulated one, clouded by the expurgation of her *Journal* and letters, principally by her husband J. Middleton Murry, whose motives were probably, at best, directed towards protecting his late wife, and, at worst, towards starting a "cult" of Katherine. Sentimental profiles such as Clarke's and excerpted love letters between Mansfield and Murry, published under such steamy titles as *Passionate Pilgrim* and profusely illustrated, have the impact of Valentine cards and demean her professionalism. Today, after some intervening years and a lessening of public curiosity about the scandalous aspects of her life, it is possible to view her work dispassionately. In addition, in the interest of satisfying those who still require a weightier body of work to measure a writer's achievement, it is possible to evaluate the stories, taken together, as larger than the sum of their parts. The New Zealand stories, for instance, have the weight of an episodic novel, much as Frank O'Connor's linked tales of his Irish Catholic boyhood do, or James Joyce's stories in *Dubliners*. Her startlingly perceptive stories of courtship, love, and marriage can stand as a cycle of personal relationships in the vein of George Moore's sonnet cycle on the subject called *Married Love* or Maupassant's collection of tales of domestic life.

It might be useful to examine Mansfield's short stories alongside the short fiction of Franz Kafka, her exact contemporary and a writer who made his mark in the short story and revealed himself in his *Journal* and letters as she did, and whose conflict with his authoritarian father, closely documented in his *Letters to My Father,* is reminiscent of Katherine's conflict with her "pa-man" father. To complete the analogy, Kafka died of

tuberculosis at the age of thirty-one after a long, anguished, fully recorded struggle with the disease. Like Mansfield, he left a lot of unfinished work for his editor to sort out. Also, like Mansfield, he was, both in his life and art, a divided person. To have been a Jew in turn-of-the-century Prague was to experience guilt and pessimism, attitudes that became the center of his moral vision. Mansfield's colonial origins, which she bore with a mixture of nostalgia and chagrin, rendered her, like Kafka, a divided self, never completely at home in Europe, where she did most of her writing, and chafing when she returned to New Zealand. But the bohemian self-exiled Mansfield, the epitome of the "modern" in her personal life, never became a "modernist" in her fiction, whereas Kafka's fiction is a very textbook of modernism.

John Updike, in his foreword to *The Complete Stories* of Franz Kafka, writes that "sixty years after his death, Kafka epitomizes one aspect of modernism: a sensation of anxiety and shame, whose center cannot be located and therefore cannot be placated." Updike notes that Kafka's stories are marked by a great deal of building towards the formulation of plot, with a lot of contortion in the process, but rarely does he complete his fictional journey. Mansfield's stories are exempt from these hallmarks of modernism. As daring as she was in touching upon subjects that were still avoided in her day, her stories are relatively free of the modernist angst that marked Kafka and his European contemporaries. Structurally, her stories, unlike Kafka's, are, with rare exceptions, complete. If the term "well made" could be expropriated from the theater to apply to narrative fiction, Mansfield's stories, like Somerset Maugham's, might be regarded as relentlessly well made. Even her fragments demonstrate discernible movement towards resolution. The division within herself did not direct her, as it did Kafka, towards extended psychological preparation for action that often did not develop. Her backgrounds, both actual and psychological, internal and external, are shrewdly and efficiently laid down in preparation for a dramatic moment of crisis that ends in epiphany as well as resolu-

tion. "The Dill Pickle" and "Bliss" are illustrative of her creative process. Although neither ends happily, each concludes with a resolution responsive to the story's central theme. In both stories, the characters are forced by incontrovertible evidence to confront the truths of their lives that are pushing up through thickly planted and cultivated illusions. The stories end without a trace of moral ambivalence and with no psychological issue unresolved.

Perhaps the key to Mansfield's carefully finished stories lies in her essential personal difference from modernists such as Kafka. The most apparent distinction between them is that while he was philosophical and mistrusted the politics and culture of his society, as did his fellow modernists James Joyce and Thomas Mann, she did not. This bohemian daughter of a Victorian colonial family never doubted her personal safety nor her political survival. She could always go home again, and she often did, both literally and nostalgically. Therefore her fiction simply does not concern itself with the anxiety, guilt, and anomie associated with modernism. On another level, the vocational one, she differed from most of the modernists as well. Kafka, for instance, left instructions to have his manuscripts burned after his death. Like many of his fellow modernists, he was ambivalent about his choice of career. Mansfield was not. She was determined to publish as much as she could and struggled to complete as many of her stories as possible in the face of her failing powers. Even as she shuttled from one place to another in search of restoration, she wrote incessantly to her friends about her race to beat the clock. A letter to Lady Ottoline Morell is typical. She wrote it while she was partially bedridden and struggling to complete the ambitious "The Daughters of the Late Colonel": "I couldn't stop. I wrote it all day and on my way back to bed sat on the stairs and began scribbling the bit about the meringues." Her debilitating disease did not exempt her from work. Unlike Kafka, who worked on and off on projects that he never finished, she treated her illness as a goad to her creativity.

To place Mansfield in critical perspective with her contemporaries, her personal and professional relationships with two literary giants of her day should be considered. D. H. Lawrence and Virginia Woolf were significant presences in Mansfield's life—Lawrence personally and Woolf professionally. She met Lawrence in 1913, when she and Murry, like Lawrence and Frieda Weekley, were living together but not yet married. Although Jeffrey Meyers declares that Lawrence was destined to have a "profound emotional impact" on her, he appears to have had no literary influence on her at all. When she and Murry joined with Lawrence in a short-lived publication venture, a magazine called *Signature*, she was harshly critical of Lawrence's writing. Even years later, when she disapproved of something she had read, primarily for looseness of structure or self-reference that bordered on the egotistical, she would condemn it as a "*Signature* style of writing." The little magazine lasted for only three issues, at the end of which Mansfield dissociated herself from the entire venture, expressing disappointment with Lawrence's contribution—a personal essay with fictional overtones, called "The Crown."

If Lawrence's fiction had no influence on her work, Katherine and Murry, as personalities, had a striking impact on Lawrence. He used them and his feelings about them in a number of short stories, and modeled Gudrun Brangwen on Katherine and Gerald Crich on Murry in his novel *Women in Love* in 1920, five years after the ill-fated *Signature* enterprise. The character of Gudrun was not flattering to Katherine, emphasizing the qualities Lawrence found least attractive in her. For her part, Katherine declared the sexually aggressive and destructive Gudrun repellent. However, the two couples remained friends, and wrote for the same literary magazines, *Rhythm, The New Age*, and *Athenaeum*, during their long and occasionally stormy friendship. The bond between them was strong enough for Frieda, by then married to Lawrence, to give Katherine her old wedding ring to wear when she married Murry, and Katherine

never took it off, leaving instructions that she be buried with it. Katherine liked Lawrence for his enthusiasm and his "merry, rich, laughing self," as she confided to her friend Dorothy Brett in a letter, while her reactions to his writing remained uncharitable to the end. In 1920, reflecting on Lawrence's current work of fiction, *The Lost Girl*, she makes it abundantly clear that she could never be influenced by him as an artist: "Lawrence denies his humanity. He denies the powers of his imagination. He denies life—I mean *human* life. His hero and heroine are non-human. They are animals on the prowl. They do not feel: they scarcely speak. . . . They submit to their physical responses and for the rest go veiled, blind—faceless, mindless." Her unforgiving judgment of Lawrence may very well be explained as rancor kindled by his classifying her art as "miniature" through the thinly disguised portrait of Gudrun in *Women in Love*. Their complex relationship endured until Katherine's death. Lawrence, who rarely complained about his own lung ailment and thought the less of Mansfield for her open discussion of her symptoms, which he judged to be exaggerated, outlived her by seven years.

Mansfield's relationship with Virginia Woolf was more professional than personal. Although she wrote to Virginia and visited with the Woolfs frequently, Virginia made it clear that Katherine was not in her social class and kept herself somewhat aloof from the young colonial artist. Although the Woolfs handset, printed, and published "Prelude" in their Hogarth Press, during her lifetime they treated her with the condescension of acknowledged royalty, as the Bloomsburys surely were, to a little New Zealand upstart. After "Bliss" was published, Virginia threw the story aside with a disgusted "She's done for," but after Katherine's death confessed that she was the only writer whose talent had ever threatened her own position. Katherine, for her part, was as critical of Virginia's work as she was enthralled by the elder writer's personal qualities and social position. In her review of Woolf's novel *Night and Day* in *Athenaeum* she offered some tactful remarks about the novel's "deliberateness," but in the

privacy of her own *Journal* she slapped her for coldness and bloodlessness. She disliked Woolf's dehumanizing abstractions as much as she deplored Lawrence's excessive animal heat, the very antithesis of Woolf's defects.

The aristocratic Virginia Woolf, the bourgeois Katherine Mansfield, and the working-class D. H. Lawrence could never be considered to have constituted a "movement" or a "school" of writing. They were drawn together by accident, through mutual advantage, by professional circumstances, and the profession they had in common. They shared no stylistic qualities or social points of view. They cooperated when it suited them and engaged in sporadic rivalries. It is highly likely that the three were in fact drawn to each other by their emotional and physical instabilities, each of them being supported and protected by more stable marital partners. All three died painful and premature deaths, leaving these same mates to outlive them for many years as keepers of the flame.

9

"With Deliberate Care": The Mansfield Short Story

> A skilful artist has constructed a tale. He has not fashioned his thoughts to accommodate his incidents, but having deliberately conceived a certain *single effect* to be wrought, he then invents such incidents, he then combines such events, and discusses them in such tone as may best serve him in establishing this preconceived effect. If his very first sentence tend not to the outbringing of this effect, then in his very first step has he committed a blunder.
>
> —Edgar Allan Poe[1]

Assessing an artist's contribution to his field is tricky at best. The subject must be scrutinized in his time, in the universal terms of his craft, for his original work, and in his derivative techniques. He must be measured against other practitioners of the genre, those past and contemporaneous. His good work must be separated from his mediocre efforts, his early work from his last. Periods of productivity must be weighed against arid patches in his creative landscape. Katherine Mansfield is not exempt from such treatment. Even the negative critical judgment of colleagues and critics in her day must be counterbalanced against favorable reviews. For example, her friend and fellow writer Virginia Woolf wrote this about her less than half a year after her death: "While she possessed the most amazing *senses* of her generation . . . she was as weak as water when she had to use her mind." The truth or falsity of Woolf's harsh criticism must be

balanced against the indisputable fact that Mansfield's short sto-
ries continue to be anthologized frequently in our own day while
those of her more distinguished rival do not.

In one area, at least, the task of critical evaluation is sim-
plified by the author's scope. Mansfield, unlike most of her
colleagues, wrote only short stories. Although she began one full-
length novel, *Juliet,* she abandoned it. Notes in her *Journal* hint
at another novel extending the New Zealand theme and tenta-
tively called *Karori,* but nothing came of it. Her contribution was
to the short story only. She is probably unique in this distinction.
There is scarcely a writer of her time, and few since, who did not
go on to write at least one novel. Whether she lacked the broader
powers and vision to construct novels, as some of her detractors
have hinted, is moot. The stories she left are sufficient. Berating
her for failing to write at least one distinguished novel is analo-
gous to faulting the composer Hugo Wolf, master of the German
art song, or lied, for not writing at least one celebrated opera.

The conventionality of Mansfield's fiction—the term is not
used in a pejorative sense—is another useful factor in limiting
and directing critical evaluation. All the standard elements of the
short story are present in most of her fiction in harmonious
balance, much as the well-crafted stories of specialists such as
J. F. Powers, J. D. Salinger, and John Updike during their *New
Yorker* period. When Mansfield was experimental, it was pri-
marily in her composition of a handful of spoken monologues,
often constructed as flashbacks that reveal character, plot, theme,
and tone. Her best short stories, "Miss Brill," "The Garden
Party," "Bliss," and "The Dill Pickle," among others, are nar-
rated conventionally from a subjective point of view. They com-
prise integrated elements of the short story as it has been defined
by theorists such as Poe in the nineteenth century and Frank
O'Connor in the twentieth.

The single most palpable quality permeating Mansfield's
stories is her perfectionism. The exemplary New Zealand cycle,
episode by episode, through character and conflict, develops with

single-minded intensity a unified theme of complex family life recollected through a veil of nostalgia for an unrecoverable past. The action varies but the setting is remarkably unified, supporting the controlled tone of longing. In its finished state, "Prelude" offers the clearest evidence of its author's relentless polishing. Compared to "The Aloe," the original version of the story written just a year earlier, the final story shows clear evidence of "much reshaping and rewriting," according to Murry's introductory essay.[2] In short order the reader discovers the truth of Murry's description of the first version as "less perfect," and agrees with him that the belated publication of "The Aloe" many years after Mansfield's death does indeed offer the "more critically minded a unique opportunity for studying Katherine Mansfield's method of work."

It is instantly apparent that the intensity and compression of "Prelude" are achieved through the author's conscientious, almost excruciating, editing. Throughout the text single words have been altered, excised, and shifted from one position in a given phrase to another. The casual reader might not notice these seemingly insignificant changes, but the text in its entirety shines more brightly as well as gaining in precision. For example, in "The Aloe," when Lottie and Isabel are put to bed in the new house, they lie down "back to back, just touching." In "Prelude" Mansfield amends the phrase to "their little behinds just touching." The second description is anatomically more correct, as the children's bodies are curled into a ball, and only their backsides touch in that position. If they were "back to back," they would be envisioned in a ramrod posture, unnatural if not downright impossible. Further, there is something childlike and vulnerable about the second phrase that is well suited to the affectionate tone. In contrast, an amendment away from the infantile is made in one of the most dramatic sequences in "Prelude." When the handyman has decapitated the duck for that evening's dinner, Isabel, watching the headless body waddling along the path, squeals, "It's like a funny little railway engine." The original

version in "The Aloe" was "It's like a funny little darling engine."
The seemingly trivial substitution of the word "railway" for
"darling" is more calculated than would appear. If indeed "these
kids are real," as one impressed reader was to observe, their
"realness" had to be consciously convincing. Isabel was the eldest
and the most likely to frame a simile or analogy drawn from her
own experience. The adjective "darling" would be more suitable
to the young inexperienced Kezia.

Other judicious editing excised repetitions of descriptions
such as the portrait of Mrs. Fairchild that appears twice in the
original. The character of Stanley Burnell is softened into a more
sympathetic figure in "Prelude." In "The Aloe" he is described as
a "ginger whale," but in "Prelude" his ginger whiskers remain
but he is drawn in more human terms. By and large, it is a small
alteration but a shrewd one. It would be difficult for the reader to
imagine the beautiful and fastidious Linda Fairfax agreeing to
wed and bed with a "ginger whale."

There are larger slashes in "Prelude" that are instantly appar-
ent. "The Aloe" contains an eleven-page digression that Mans-
field removed, probably to incorporate it into a third part of the
cycle. In the interest of preserving a unified point of view she did
well, because in these pages her narrative shifts suddenly from
Kezia, who has been the center of sentience, to her mother. It
justifies Linda's detachment from her children through a flash-
back showing her devotion to her father, her longing to travel,
and her resistance to marriage. But the section, which is indeed
illuminating, threatens the integrity of the whole and Mansfield
wisely excised it. Ultimately Linda's point of view is presented
more subtly in "At the Bay," where she and the other adults are
the focal figures. One other lengthy episode involving Linda,
Beryl, and another sister at afternoon tea, probably designed to
show the differences in the three Fairfax sisters—and surely a
reflection of the Beauchamp sisters—is scrapped and saved for
another story. It is preserved in an unfinished state in the *Scrap-
book*.

Character in fiction is either "flat" or "round," which is to say stereotypical or multidimensional. Mansfield's characters are primarily round—that is, faceted and like "real" people. Even her minor characters—Pat the handyman in the New Zealand stories, Cyril, the wastrel grandson in "The Daughters of the Late Colonel," and the "literary gentleman" in "The Life of Ma Parker"—have distinguishing qualities that individualize them. For example, when Hennie, the small boy in "The Young Girl," buries his face in his cup of chocolate, his childish delight is captured in his emerging nose, on which hangs a blob of cream. His wholehearted immersion in the treat and his subsequent scarlet-faced humiliation frame him as an endearing child and as an effective counterpart to his sullen sister.

Mansfield can sink a character through a single word and still avoid creating a "type." The irritating genteel nurse in "The Daughters of the Late Colonel" has a laugh "like a spoon tinkling against a medicine glass." In "Marriage à la Mode" Moira Morrison's arty triviality is encapsulated in her painstaking analysis of the appearance of her legs under water, which she concludes are "the palest mushroom colour" to everyone's edification. A Russian cigarette case pulled from the pocket of the unnamed former lover in "The Dill Pickle" tells the story of his selfishness. It is a mute reminder of a broken promise and its owner's callousness. His onetime companion is reminded of their dreams of traveling to Russia together and of his fulfilling their shared plans without her. His guilelessness in offering her the Russian cigarettes in their native case and his hearty recounting of his adventures make his unthinking cruelty memorable.

As well plotted and carefully constructed as Mansfield's stories are, they cannot be confined to any single tradition. The two recognized historical "schools" are the psychological tradition laid down by Poe and the socially observant tradition associated with Maupassant. There are other categories as well: the plotted and the plotless story, the stories of initiation, symbolist stories, and so on. The categories are both endless and overlapping, but

Mansfield, like other writers, cannot be confined to any single formula, whether it be the rules set down in Poe's "The Philosophy of Composition," Chekhov's social realism, James's psychological realism, Maurice Maeterlinck's symbolism, or Joyce's stream-of-consciousness technique. Her short stories do not fit into any single framework, any more than does the entire body of Cheever's or Updike's short fiction. As she wrote, she continued to experiment. "Her First Ball" and "The Garden Party" are stories of initiation. They are also fully plotted psychological studies. They have some traces of social realism. "Je ne parle pas français" is a rare attempt at plotlessness. The story "Psychology" is not psychological but a fragment designed to produce a "single effect" with "deliberate care" in obedience to the Poe formula.

Mansfield's youthful devotion to Wilde's brittle comedy surely is responsible for the languid witty dialogue in "Marriage à la Mode" and "Bliss." "A Cup of Tea" is the perfect magazine story. It has all the elements required for a popular journal, including a surprise ending. Its slick commercial "feel" does not negate the perfection of its construction. "Poison" and "Taking the Veil" are effective demonstrations of the symbolist credo that states of mind are most effectively conveyed through concrete images. "The Child Who Was Tired," Mansfield's most feeling and conscious tribute to Chekhov's social realism, is actually far removed from Chekhov's profound but abstract social concern. Chekhov's "Sleepy" expresses his outrage against societal abuse; it is a protest against oppression and close to political socialism. Mansfield's version is more personal and limited. Her sad story focuses on the child herself as a helpless object of personal cruelty, not social injustice. Her symbolical ending of the child's dream gives the story a twist towards the allegorical. Chekhov's has none of that fanciful quality. His story is close to being a documentary of social inequity, its central character serving as an instructive example of victimization.

The following stories reveal still other debts to traditional sources even as they bear the stamp of her originality. "The

Canary," a first-person oral monologue to an unseen audience, is reminiscent of Poe's unidentified monologists whose narrations explain their current emotional state in terms of their past history. The speaker in "The Canary" begins: "You see that big nail to the right of the front door? I can scarcely look at it now and yet I could not bear to take it out." The story is secondary to the tone and symbolism. The speaker is highly agitated. Her loneliness is implicit in her attachment to the dead bird, itself a symbol of her yearning for beauty in a pinched sterile life. The nail that held the suspended cage remains on the wall as a symbol of her loss and pain. It is a nail driven through her heart.

In "The Garden Party" also, literal objects have a wider symbolic reverberation than their limited objective selves. When Laura Sheridan leaves the party on her mission to the bereaved family of the dead man, "the kisses, voices, tinkling spoons, laughter, the smell of crushed grass [are] somehow inside her." As the great lawn recedes in the distance behind her, a newer unfamiliar reality is symbolized by the narrow dark lane leading to the cramped hovel in her line of vision. "Women in shawls and men's tweed caps" supplant the trailing skirts and frock coats of the afternoon's festivities. Shadows replace sunlight, silence follows the murmur of tea-party chatter. Only the large garden-party hat, still propped on Laura's bowed head, remains constant, worn in the dusk as a badge of penance as it has been worn in daylight as a symbol of her corruption.

Socially observant narrative that makes its point through irony in the Maupassant tradition may be discerned in plotted stories like "Sixpence." Mrs. Bendall, a timid woman, is bullied by Mrs. Spears, an overbearing visitor, into goading her husband to whip their beloved small son. The child's infraction is minor, and the family is loving and forgiving. Under subtle criticism of her "superior" neighbor, Mrs. Bendall is made to feel incompetent and lax in the performance of her "moral" duty, introducing a new and ugly atmosphere into her peaceful home. Her tired husband, angry at being assaulted by his overwrought wife to do

his duty as a man, whips the child, and is crushed by the child's forbearance in his pain and humiliation. The worm has been found in the apple. The child forgives his parents but their happiness has vanished.

The irony of the serpent's evil in this Eden is implicit in the throwaway remark about Mrs. Spears's own "exemplary" sons. They have indeed attained perfection in deportment, but it is noted that they prefer to play outside their home, in the toolshed, behind the kennel, even in the trash bin. Her callers marvel that "you would never know there was a child in the house." Mrs. Bendall then recalls that "in the front hall of her neighbor's well-run home, under a picture of fat, cheery old monks fishing by the riverside, there was a thick dark horsewhip."

The contrast between Mrs. Spears's "soft sugary voice" and the repeated brutal whippings that have shaped her children's decorum is an irony lost on Mrs. Bendall but not on the reader. Her visitor's hypocrisy in the execution of her maternal obligation is yet another unnoted irony. Does Mrs. Spears administer the whippings? Of course not. It would be unseemly for a mother, the symbol of nurture. Who does it then? Why, their father, of course—the respected symbol of authority. Ironically, just as Mrs. Bendall, under the influence of her persuasive friend, is working herself up to persuading her husband to inflict corporal punishment on his beloved child, he "staggers up the hot concrete steps . . . hot, dusty, tired out," and spoiling for a fight. He needs no convincing. "He felt like a man in a dark net. And now he wanted to beat Dicky. Yes, damn it, he wanted to beat something." The story ends on yet another ironic note. The beaten child, holding up his face in forgiveness, wipes out the father's rage and accepts the sixpence offered him in penance by his father, who is now beating himself for his unprecedented act of brutality.

This is a story crammed with irony. Whereas little Dicky Bendall makes his small mischief in the open, Mrs. Spears's model sons do theirs secretly, away from the bullwhip. In the

arena of conflict the tables are turned and turned again. The timid mother is ironically stripped of authority in her own home and is forced into violating her principles. The "superior" guest is exposed as inferior in human terms. All the plotting of the two women to force the man to an act abhorrent to his nature proves to be unnecessary. He has come home in a brutalized condition and was ready to assault someone. "Sixpence" is withal a touching story in its understanding of frailty and the ironies of interpersonal maneuvering for power. The symbols of the omnipresent whip, the sugary voice, and the sixpence coin are effective emblems of control and subordination. It is worth noting that Mansfield must have taken Chekhov's observation about "props" in the theater seriously and adapted them to her own use of symbols. His remark that the audience may be sure that the gun hanging on the wall in the first act is bound to go off in the third is applicable to Mansfield's use of emblems, from the first mention of the tight headband on Mr. Bendall's head to the angry pucker left by his hat when he beats his child at the end.

Mansfield culled her characters from all levels of society, from the privileged station of the Sheridans to the shabby rooms of Ma Parker, from New Zealand to the Continent, from the beefy Germans of the Bavarian Alps to the fleshless spinsters of post-Victorian England. Her themes are manifold. Like all serious writers she tried to tell the truth about her own life, the life about her, and the imagined life. In short, her contribution to the genre of the short story cannot be neatly categorized. She ranged far and she roamed freely, but certain conclusions may be drawn as a guide to the basic constants in her fiction.

Her technique is invariably efflorescent—from the bud to the flower, so to speak. She begins with a single incident or clue, such as the landlady's intrusion into Miss Ada Moss's room in "Pictures" or the unblemished weather on the day of the Sheridans' garden party. We take it on faith that the tension in the story will derive from that single bit of information. She rarely disappoints us. She builds on the fragment layer by layer, estab-

lishing the mood—almost always an atmosphere of psychological tension—until the small incident, which Henry James used to call the "germ," unfolds into crisis, climax, and resolution.

A prevailing mood of tension is a constant in Mansfield's work. Unlike her literary model Chekhov, who did little by way of manipulation after he laid down the bare facts of his characters' troubles, she adds, alters, and controls. Miss Brill's illusory self-image is shattered when she is forced to confront herself in a glass held up by her detractors. Laura Sheridan's innocence is destroyed step by step in a calculated series of ugly events that oblige her to confront the truth about her insulated life and the tragedy of others. The unsuspecting lover in "Poison" is forced by an insignificant incident—his mistress's casual inquiry about the mail—to face her inconstancy. Unrelieved tension is the governing mood of the allegorical "A Suburban Fairy Tale," generated by irremediably obtuse parents and their imaginative child.

In stories such as "Prelude," "Her First Ball," "The Doll's House," and "Bliss," tension is created through a contrived alternation between fulfillment and deprivation, satisfaction and yearning, self-indulgence and guilt. Their total sustained effect is one of delicate balance between opposing forces that prevail to the end. Witness the unanswerable question Bertha asks at the end of "Bliss" and Laura's unfinished question at the end of "The Garden Party." They keep their climate of mystery to the very end because their underlying tension is unresolved.

Finally, Mansfield's stories are usually "good reads." Their meaning is accessible even to the general reader who does not wish to trouble his head about the hidden significance in her fables. Their point of view is almost uniformly subjective, and their dialogue is witty, often sparkling. Her narration is economical and colorful, rarely discursive. Her most successful stories are those that originate in her own childhood, her love affairs and marriages, and the characters she encountered in her travels. Her least successful stories are static monologues such as "A Married Man's Story" and "The Lady's Maid." Taking Brander

Matthews's definition of the true short story as "complete and self-contained" and marked by a "single effect," we may conclude that Mansfield's finest stories have the requisite "totality" of the prescription.[3] If she failed to rise to James's mandarin detachment, or Chekhov's selfless compassion, or Joyce's psychological intensity, she left at least two dozen works of brilliance and polish and a smaller number of perfect stories.

Notes

1. The Life as Source

1. The biographical information in this chapter is drawn, except where otherwise noted, from the two most recent and most meticulously documented studies of the subject's life: Jeffrey Meyers, *Katherine Mansfield: A Biography* (London: Hamish Hamilton, 1978), and Antony Alpers, *The Life of Katherine Mansfield* (New York: Viking, 1980). Mansfield's *Journal, Letters,* and *Scrapbook* have been consulted for authentication along with memoirs, biographies, and letters of her contemporaries.

2. The term "pa man" appears to be a shared Beauchamp family allusion. The original pa man, according to Alpers (p. 7), was Arthur Beauchamp, who was a good-natured but somewhat incompetent bungler. In later years, the term was altered subtly to apply to the more authoritarian and blustering Harold, who, transformed into the fictional character of Stanley Burnell, was nevertheless touchingly vulnerable. Katherine and her brother Leslie used the noun as a description, occasionally referring to some act as "very Pa." In the *Journal* (p. 4) Katherine writes, "What a Pa man!" in response to a poem Dorothy Wordsworth had written about her celebrated brother William's compulsively ordered daily routine.

3. In "Juliet," she is actually describing herself when she writes: "She had been as yet, utterly idle at school, drifted through her classes, picked up a quantity of heterogeneous knowledge—and all the pleading and protestations of her teachers could not induce her to learn that which did not appeal to her."

4. The five stories about childhood written between 1903 and 1905 are "The Pine Tree," "The Sparrows," "You and I" in 1903, "Your Birthday" in 1904, and "About Pat" in 1905.

5. The only mention of this pregnancy appears in *Katherine Mansfield: The Memories of LM* (New York: Taplinger, 1971). Her

account reads: "Katherine realized that she was again with child. She wrote repeatedly to the young man and begged him to come and see her, but she never had any reply. . . . So he never knew of the child."

6. Katherine's notoriety for her sexual profligacy was of such a dimension during the years of her love affairs that Virginia Woolf commented when she met her that she had "gone every sort of hog ever since she was seventeen," and had had "every sort of experience."

7. Mary Middleton Murry, *To Keep Faith* (London: Constable, 1958), p. 167. The excerpt is from Murry's diary of March 10, 1954.

2. The New Zealand Cycle: A Bildungsroman

1. Mansfield's New Zealand stories and Joyce's *Portrait of the Artist as a Young Man* may be technically defined as autobiographical fiction and Bildungsroman. The first is fiction in which the identity of the characters is disguised in name, freeing the author to rearrange and even distort the facts for the purpose of dramatizing the themes that are central to the narrative. The latter, or the "novel of development," may invent a character, such as Holden Caulfield in *The Catcher in the Rye*, or Pip in *Great Expectations*, and trace his intellectual, spiritual, or artistic maturation. Both genres frequently overlap but are not synonymous.

2. The name "Kezia" is derived from "cassia," a tree indigenous to warm climates and pronounced like "desire." It was chosen because it was close to Mansfield's own nickname, "Kass." Alpers, p. 190.

3. Marvin Magalaner, *The Fiction of Katherine Mansfield* (Carbondale: Southern Illinois University Press, 1971), p. 27.

4. "The Aloe," the first version of "Prelude," draws more specific attention to the central image of the narrative. When Mansfield revised the story, she excised the only positive reference to the plant: "The fresh leaves curled up into the air with their spiked edges; some of them looked as though they had been painted with broad bands of yellow." The aloe in "Prelude" is a negative image.

5. The suggestion of homosexuality in "At the Bay" is developed much more explicitly in "The Aloe" of 1916.

6. The term originates with Lionel Trilling in his introduction to *Huckleberry Finn* (New York: Rinehart, 1948).

7. Jeffrey Meyers's *Katherine Mansfield: A Biography* (London: Hamish Hamilton, 1978) does in fact contain such a collection of photographs of Mansfield herself, between pp. 82 and 83.

8. The following is the account offered in Alpers's biography, p. 46: "Kathleen's sister Vera, when asked by the author if there had ever been a garden party like the one in the story, and was there an accident that day, replied, 'Indeed there was,' and added, faintly bridling, 'And *I* was the one who went down with the things!' She then described how absurd she felt in 'one of those enormous hats we used to wear in those days,' and how she had to tilt it sideways to get through the cottage door."

9. The fictional Kelveys in "The Doll's House" were modeled after the real MacKelveys, the daughters of the Beauchamps' washerwoman and her shiftless husband, who was not, however, in prison. Sylvia Berkman, *Katherine Mansfield: A Critical Study* (New Haven: Yale, 1951), p. 89.

3. *In a German Pension:* The Exile as Satirist

1. The point of view will change from one male to another. Halfway through, the story is narrated by the doctor. Although Frau Binzer is the subject of the story, her point of view is not given.

2. Frank O'Connor, "Author in Search of a Subject," *The Lonely Voice* (New York: Meridian, 1965), pp. 133, 128–142.

4. Trouble in Paradise: The Marriage Stories

1. In one of her letters to her mentor, Thomas Wentworth Higginson, Dickinson wrote: "You mention immortality. That is the flood subject."

2. Berkman, p. 46.

3. Ida Baker, *Katherine Mansfield: The Memories of LM* (New York: Taplinger, 1971), p. 53.

4. John Ruskin, "Of Queen's Gardens," *Sesame and Lilies* (London: Smith, Elder, Cornhill, 1865).

6. *The Urewera Notebook:* The Wilderness as Source

1. *The Urewera Notebook* is as much the work of Ian A. Gordon, its editor and annotator, as it is Mansfield's. Gordon's thirty-page introduction is as long, if not longer, than Mansfield's scrawled unpunctuated notes. Gordon's intertextual notes and links give order to a fragmentary, often indecipherable, writer's notebook. Excerpts quoted in this book retain the sentence fragments Gordon permitted to stand.
2. Anton Chekhov, *Letters on the Short Story, the Drama, and Other Literary Topics* (New York: Bles and Minton, Balch and Co., 1924), p. 70.

7. *Novels and Novelists:* The Writer as Critic

1. Mansfield gives Lawrence a mixed review in her informal rating of *Aaron's Rod.* "There are certain things about this book I do not like," she begins, and then praises its intensity. *Novels and Novelists* (London: Constable and Co., 1930), p. 308.
2. The *Scrapbook* entries can be confusing. There are as many passages copied from Dostoyevski's fiction as there are critical comments. Mansfield does not often distinguish between her own critical writing about writers she admires and verbatim excerpts from their work.
3. *The Collected Letters of Katherine Mansfield,* edited by Vincent O'Sullivan and Margaret Scott, volume 1, 1903–17 (Oxford: Clarendon Press, 1984).

9. "With Deliberate Care": The Mansfield Short Story

1. Poe's statement of his theory of the short story appeared in *Graham's Magazine*, May 1842, in a review of Hawthorne's collection of short stories titled *Twice-Told Tales*, and was later revised to appear as "Tale-Writing" in *Godey's Lady's Book*, November 1847. The epigraph is taken from the 1842 version.
2. Although "The Aloe" was written in 1916, it was not published in her lifetime. Murry published it posthumously in 1930, explaining that it could not be included in *The Short Stories of Katherine Mansfield* because "it repeats, in a less perfect form, the material of 'Prelude.'"
3. Brander Matthews, "The Philosophy of the Short Story," *Short Story Theories*, ed. Charles E. May (Athens: Ohio University Press, 1976).

Bibliography

Books by Katherine Mansfield

In a German Pension. London: Stephen Swift, 1911.
The Short Stories. New York: Knopf, 1920.
The Journal. New York: Knopf, 1927.
The Letters: Two Volumes in One. Edited by John Middleton Murry.
 New York: Knopf, 1929.
The Aloe. London: Constable, 1930.
Novels and Novelists. London: Constable, 1930.
The Scrapbook. New York: Knopf, 1939.
The Urewera Notebook. Oxford: Oxford, 1978.
The Collected Letters. Volume 1, 1903–17. Edited by Vincent O'Sullivan and Margaret Scott. Oxford: Clarendon, 1984.

Books about Katherine Mansfield

Biographies

Alpers, Antony. *The Life of Katherine Mansfield*. New York: Viking,
 1980.
Baker, Ida. *Katherine Mansfield, the Memories of LM*. New York:
 Taplinger, 1971.
Meyers, Jeffrey. *Katherine Mansfield: A Biography*. London: Hamilton,
 1978.

Critical Studies

Berkman, Sylvia. *Katherine Mansfield: A Critical Study*. New Haven:
 Yale, 1951.
Magalaner, Marvin. *The Fiction of Katherine Mansfield*. Carbondale:
 Southern Illinois University Press, 1971.
Rohrberger, Mary H. *The Art of Katherine Mansfield*. Ann Arbor:
 UMI, 1977.

Theory of the Short Story

Chekhov, Anton. *Letters on the Short Story, the Drama, and Other Literary Topics*. New York: Geoffrey Bles and Minton, Balch and Co., 1924.

May, Charles E., editor. *Short Story Theories*. Athens: Ohio University Press, 1976.

O'Connor, Frank. *The Lonely Voice: A Study of the Short Story*. New York: Meridian, 1965.

Index